Monochrome Magic
RyanPhotography

Foreword

One of our passions in life is taking photographs. In fact it is a passion of both of us... yes we are husband and wife, with 4 cameras and a couple of dogs thrown in, just for good measure. We have been totally smitten with the photography bug... and learning this wonderful hobby we decided to take up.

There is nothing better than getting out there in the fresh air and finding those exquisite places to photograph.

Once you are bitten by the photography bug, that is it... no place ever looks the same again.

As you drive by places, that you have travelled by a hundred and one times before, you start to see the architecture of places, whether the architecture adds to the composition of the photograph. You start to see things in a whole new light ... Your eye automatically looks at places differently and you mentally take note of how good that building is... and how great that landscape would look in a photograph.

Photography is what you make of it... and you definitely don't have to be a professional photographer to enjoy this wonderful pastime.

Every picture tells a story... and this is the story of our photographic moments captured in Monochrome.

Learning Your Camera and the Software Needed

So you have just gone out and purchased your new camera.. Yes, you did your homework, you read all the reviews and opted for a camera that a) is within your price range and b) one that suits your particular needs.

You get home and open the box all excited and then take your first good look at the back of the camera and you see all those buttons…. Scream, shake, shriek… my God what do you do? Do you box it back up? Or do you take the bull by the horns and start to fiddle with those buttons. Well firstly don't panic and take the bull by the horns… fiddle with the camera.. Learn what those buttons do… read the owner's manual and don't fear… one advantage of many new cameras is this… it has a fantastic setting called FACTORY RESET.

You can play around to your heart's content with those buttons without fear of ruining your camera. You can easily revert to the default settings that your camera came with just a click of a couple of buttons.

Looking back on our photographic journey, we were just point and shoot people. We had a camera that was good enough to take the odd photographs and the odd family portraits and that was it… we knew nothing else about photography.

Seriously, if someone had said f-stop, aperture, shutter speed and ISO, to either of us… with our hands on our hearts we would have thought that they were swearing at us and probably punched them.. No I am just joking there.

Our first digital camera was a Samsung Digimax 420 which was bought for me as a Christmas present… many, many moons ago. Yes we had the normal film cameras, but to be honest, we rarely used them due to the expense of processing the films. Digital cameras were the new thing.. And this little camera was one of the first one's out. I still have that camera today… I just can't bring myself to throw it out.

Christmas 2007 arrived and the male half of RyanPhotography decided he wanted to purchase another camera and he opted for the Fuji FinePix S5700 camera from Amazon priced at about £150. It was an ideal camera and at the time we didn't even have an inclination to go into photography so this little camera served us well for about 5 years. It produced decent quality pictures … far better than the Samsung Digimax… and we thought those photographs were of brilliant quality. What novices we were.

Five years later… we purchased our first Canon camera the Canon EOS 1100D and I was handed down the Fuji FinePix to use… But the problem with that camera was… it was battery operated and it would eat through the batteries. It would cost an arm and a leg in batteries to go out shooting for a full day.

This prompted us to purchase a Panasonic Lumix FZ48 bridge camera. It was ideal for me and I was given it for my anniversary present… looking back even though I love that little camera for zooming into objects… it has its limitations with regards to the fact that it only does jpeg images and not RAW.

For months I was quite contented with this camera and then Curry's had a promotion on and he decided to purchase the Canon EOS 600D, and I was handed down the Canon EOS 1100D. Then I did really learn what DSLR cameras were all about.

Software

Well when you have your new camera the first thing you want to do is upload your photographs to your computer to enhance them.. Especially if they have been shot in RAW.. Because the RAW format looks very bland and dull. Simply because jpeg images have had the editing part done in-camera… where RAW images have not.

The primary software I use is Adobe Photoshop Lightroom, which can be purchased directly from Adobe… Adobe run an excellent Photographer's Package at just under £9 per month.. Which is really the cost of giving up one Starbuck coffee each week and by doing that you get Photoshop as well as Lightroom.

This is excellent value for money. Simply put you get both programmes for £9 and you don't have to worry about re-purchasing the software should Adobe decide to update that particular piece of software. All updates come with your monthly subscription.

The main advantage of using the Adobe Photoshop Lightroom software is this.. No matter what and how many adjustments you make to your images ... Lightroom is NON-DESTRUCTIVE. Simply put... your original file stays exactly the same.. Lightroom stores all the adjustments within the LIghtroom Catalogue.

However, on saying that... Photoshop can be destructive if you are not careful.. So remember when saving your image... make sure you give it a file name different to the original file name.... Lately I have been experienced that Photoshop changes the file type automatically to psd... and as started to add a 1 to the image and as I mainly edit in Photoshop via Lightroom... Lightroom automatically created a copy of the photograph.

There are alternative software programmes, some of which are free and that includes GIMP and Picasa but for our photography I primarily stick to Adobe Software... You can still purchase Photoshop Elements which is a slimmed down version of Photoshop... but honestly for £9 a month you can't go amiss with Adobe's Photographers Package.

All photographs produced in this book have been processed in Lightroom and/or Photoshop.. If you are not conversant with photo processing there are some excellent books you can purchase and plenty of YouTube videos to get you started. Another great resource is blogs... especially those blogs that give tutorials... I find them very helpful and often resort to these resources when learning to do something in Photoshop or Lightroom.

There are many websites out there. Websites that give you tutorials... websites you can read to learn about your camera... and there are many photographers out there who are only too willing to help you and give advice and give tips and tutorials.

When I look back now... I have learnt so much... f-stops, aperture and ISO no longer frightens me... Manual mode and long exposure is something that I am now happy to experiment with.

One of the many things I like to take is Auto-Bracketed Photographs... and I have now learnt how to setup my Custom Menu with the settings I mainly use on my camera... it is a whole lot easier... to turn the dial to C than have to go through all the rigmarole of changing the settings every time I wanted to capture a 5-shot Auto-Bracketed Exposure set of images.

In today's modern technological world, if you have a SmartPhone, Tablet or Computer there is nothing stopping you... which a few clicks you can find out what you need to know and how to achieve that perfect shot.

And remember, you don't have to limit the number of shots you take... unlike you had to with film, you can always delete those shots that you don't like or those shots that are blurred, and not focussed correctly from your memory card and it doesn't cost you a penny.

Seascapes

There is nothing like the coast is there.. especially with the waves that come crashing on the shoreline and the smell of the sea air. And of course, not forgetting the doughnuts, candy floss and chips... oh how I wish they were still wrapped in newspaper... they sure tasted a whole lot better back then.

One of the first pictures we took with the Fuji Finepix was one of the steam trains that sat in Paignton Railway Station in Dorset.

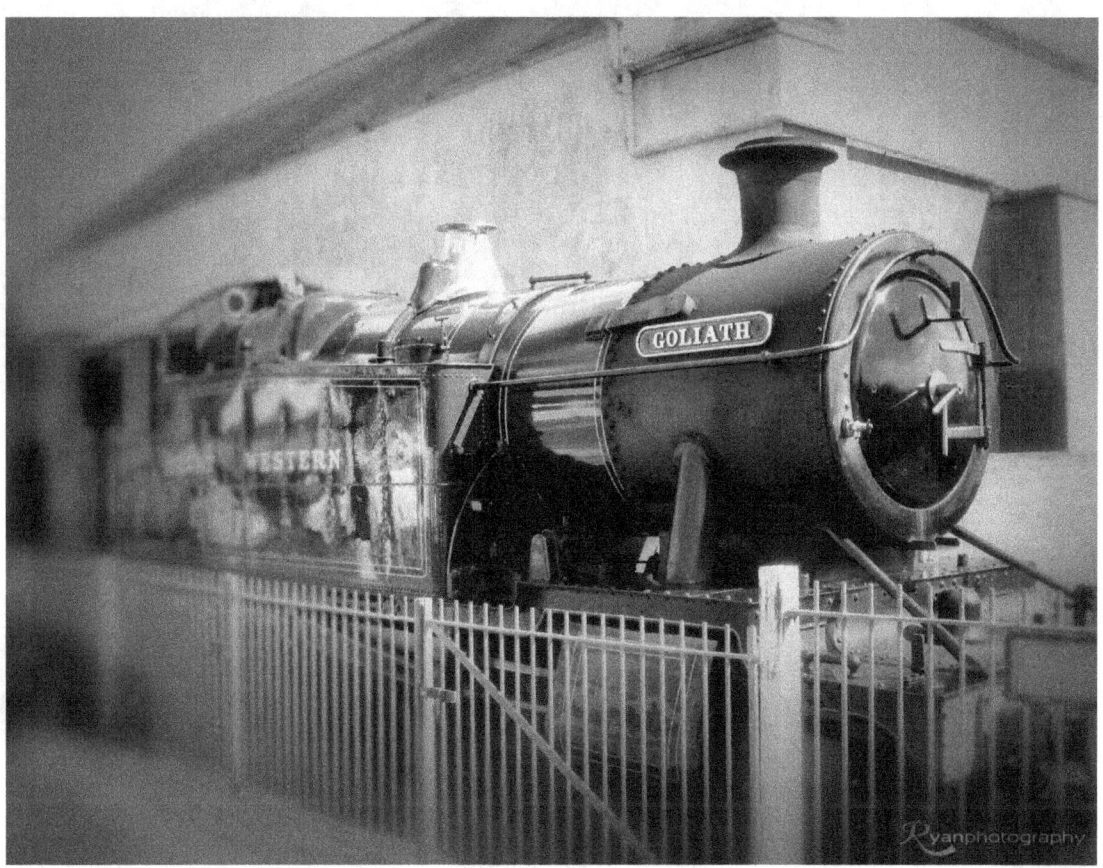

The steam train runs from Paignton to Kingswear... and you can get a ferry over to Dartmouth... Devon is a beautiful place... and one of our favourite locations for photography.

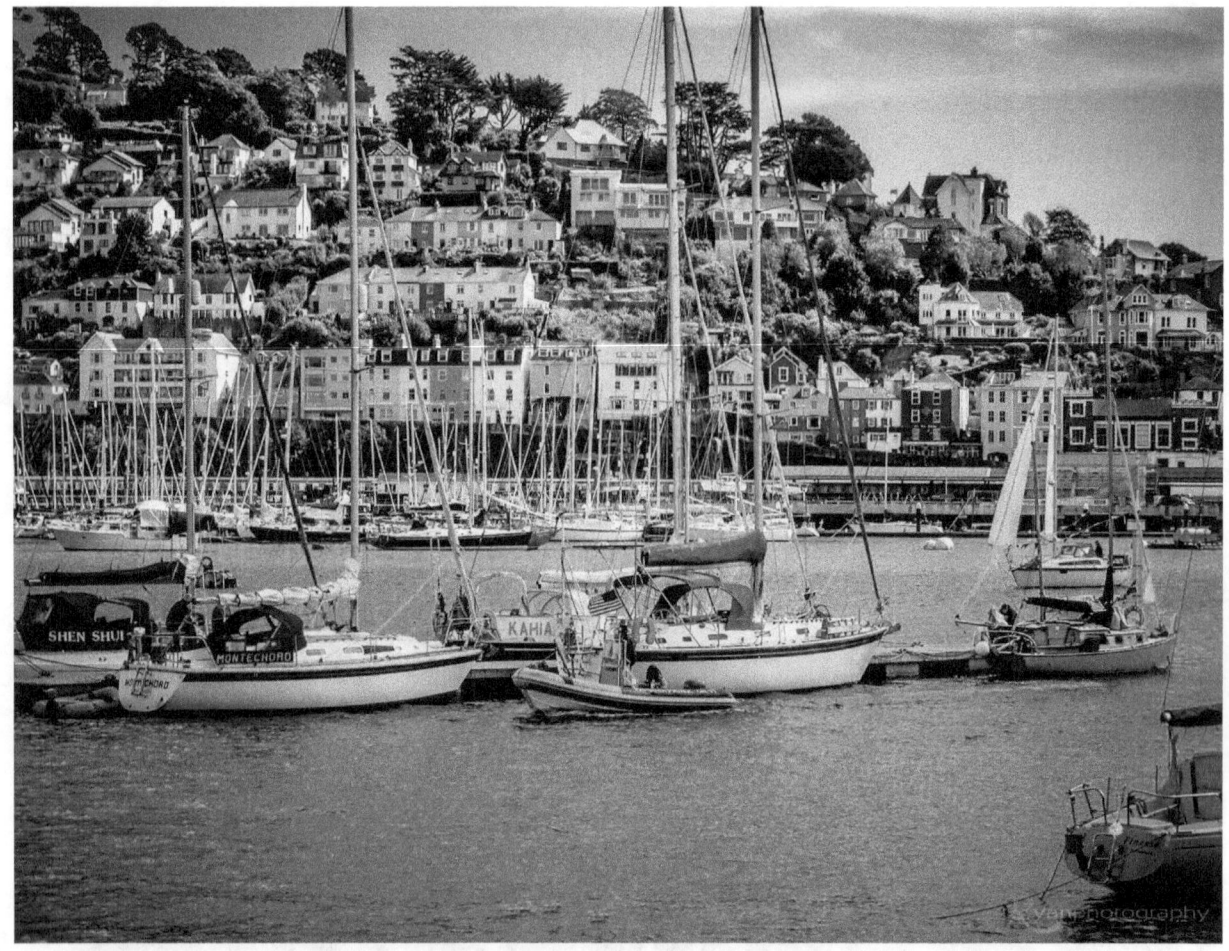

The above photograph is of the boats that moor on the River Dart, and was taken in Dartmouth looking over the river towards Kingswear.

A picture is what you make of it.. You just have to have imagination. Some people say that using the likes of Photoshop and Lightroom means you are not a real photographer. Well even Ansel Adams did a lot of his editing in the Darkroom.. And for us Lightroom

and Photoshop are our darkrooms. For me processing is part and parcel of photography and I love processing images in Lightroom and Photoshop. Photography boils down to what pleases you… and remember *'It is your image, do what you like with it'*

Towards the end of 2013, storms were battering the United Kingdom especially on the South coast. We had howling winds, high tides, surges, flooding… you name it we had it.

Just as the storms were hitting the United Kingdom we headed towards St. Leonards near Hastings in East Sussex. Bad weather had been forecast for this area, so on this particular Saturday afternoon we headed down that way… armed with our cameras and winter woolies.

Only a fool would head for the coast in such atrocious weather.. And I have always loved photographs where you can see waves and spray battering the coastline.

The waves were crashing in… and there he is under the pier getting those shots… honestly I couldn't believe he went under that pier. But as he says… sometimes you have to get your feet wet to get the shot. And believe me.. He has got his feet wet on a fair few occasions during his photography trips.

But on that particular day I would have been far happier, with those atrocious winds and huge waves, if he had stayed up on the promenade.

You can see from the following photographs how high those waves were coming in… and the longer we stayed there we found the stronger the wind was becoming and the waves were gaining in their height. You could feel the storm approaching rapidly… and so we made our retreat. It is not worth putting your life at risk and the lives of others at risk just because you want that perfect shot.

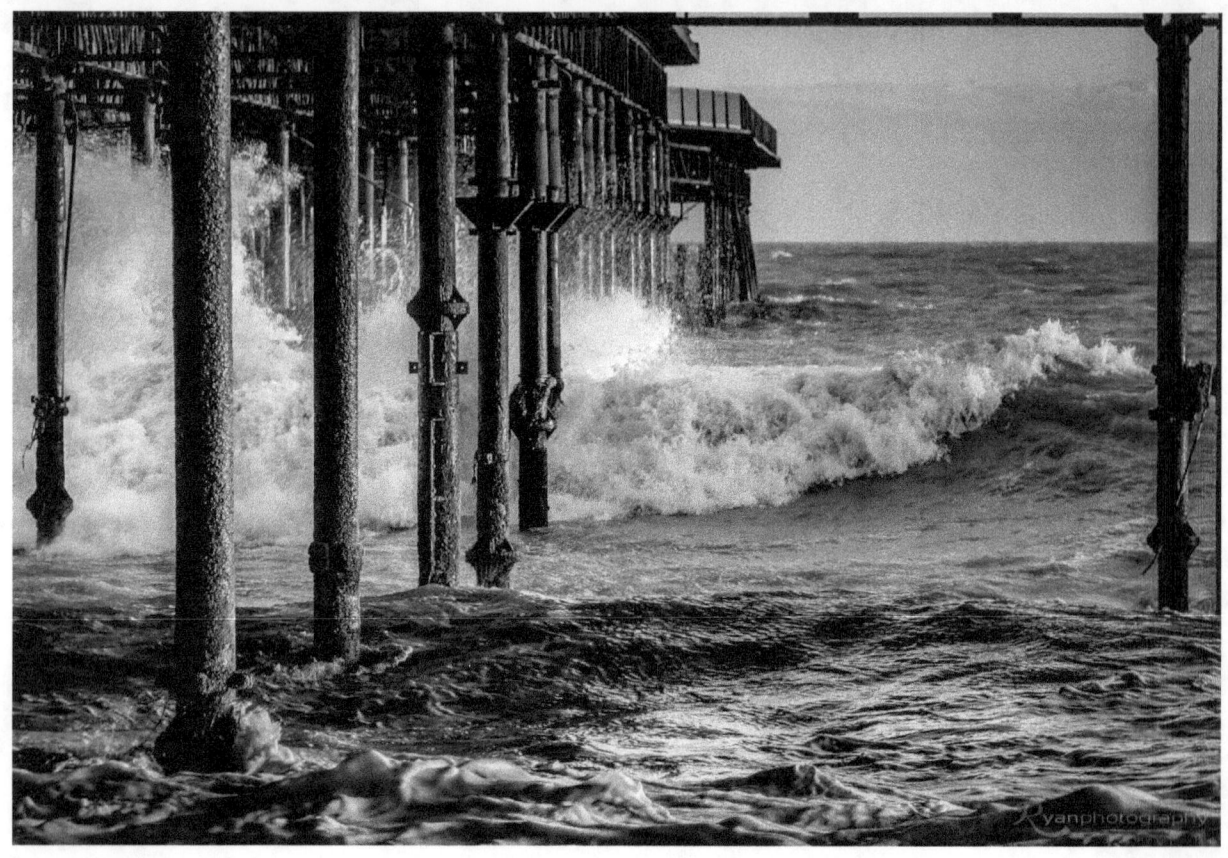

You can see the momentum of the waves and how ferrous they were getting.. And it was only after he came out from under that pier that I spied the big warning sign not to enter under the pier.. And boy that pier was in a dangerous state.

I sure wish I had seen that sign earlier.. Because he wouldn't have gone down there then... believe me.

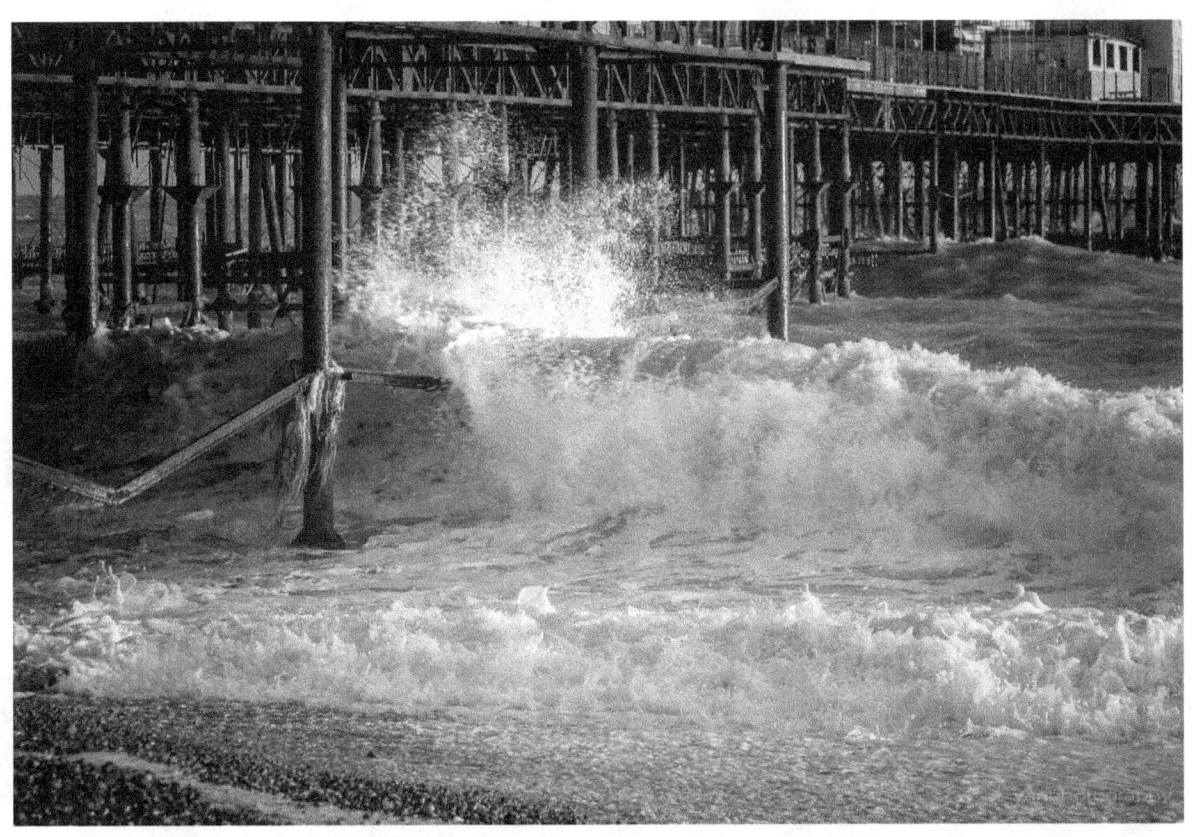

That photograph was photographed using a very fast shutter speed.. By using a fast shutter speed he was able to capture the spray of the waves as they crashed against the pier.

One thing I have started to do is alter my ISO... before I would set it to 100 and leave it.. But if you want to capture fast-moving shots or in this case a spray of water.. Then you do need to up your ISO so that you can have a fast shutter speed. ISO, Aperture and Shutter Speed form a nice little triangle and they are all dependant on each other... A high ISO can create noise.. A low f/stop will create a good depth of field.. And a fast shutter speed will capture the action. If you want to create a soft milky look to water... then have a longer shutter speed.

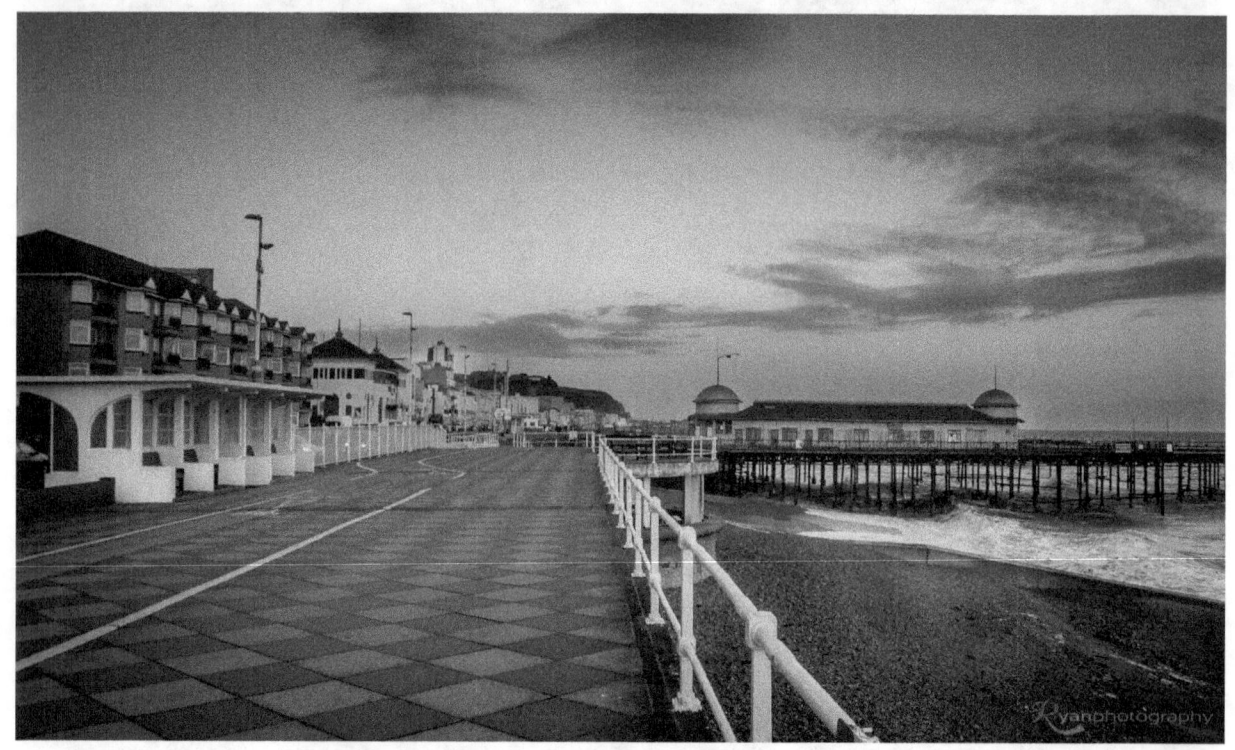

I couldn't believe that day... there was hardly anybody on that sea-front... mind you I can't blame them.. It was pretty rough weather. Only a fool would head to the coast in gale force winds... oh yes we are those fools. Not saying it was cold.. But we were thankful to hold onto those warm chips.. Even gloves had no effect that day. But it was worth getting cold for just to get those shots.

There are lots of other places that we love to travel to, and one of them is Herne Bay on the Isle of Thanet in Kent. We have been down there quite a few times on the hope that we would be able to photograph the sunset but so far we haven't had much luck.

On this particular day our trip to Herne Bay originally was to capture a sunset... but when we got there the sun was setting to the rear of the houses on the left of the picture.. The sun was fading fast and it was a quick dash to Hampton Pier which was just around the corner where we did get a sort of sunset photograph.. But it wasn't anything spectacular.

However, one of the shots that we did manage to capture on that particular day, was one of the sea cascading onto some rocks. To achieve this desired look, a tripod was used and a long exposure time of 2.5 secs with an aperture setting of f/5 and an ISO setting of 100.

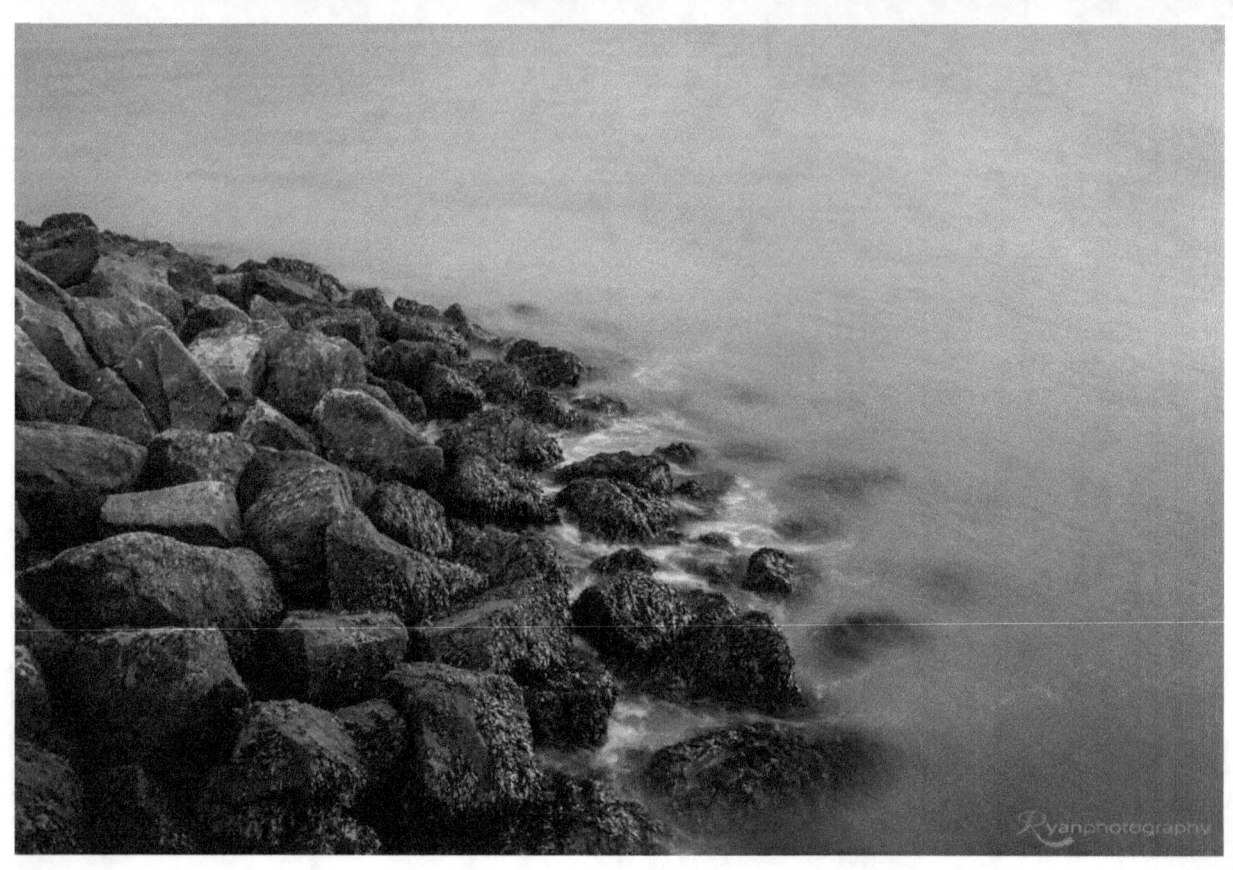

What I love about the above photograph is that by using a long exposure you get a silky effect to the water, and in this photograph was the added bonus of it looking like there is a slight mist hovering at the rock's edge.

One thing we have learnt in photography and that is to experiment. If you really knew how many photographs were taken to get that one shot you would be amazed. It was trial and error until, eventually, the right settings were found. On the Canon EOS 600D you have a remote control so that you can easily setup your tripod, dial in your settings and then use the remote control to take your shot. By using the remote you eliminate camera shake. On the Canon EOS 1100D you can purchase a shutter release cable.. And we have found this is better than the remote control simply because the remote sensor is at the front of the Canon EOS 600D and 70D. But if you haven't got a remote or a shutter

release cable then a delay setting of 2-5 seconds is enough for you to be able to move away from the camera, so that there is no chance of any camera shake. Also a handy tip I have is because my tripod is lightweight... I hang my camera bag on the hook to give it more stabilisation.

Even a piece of driftwood by a river can provide the perfect shot. The following photograph was taken at Gillingham Country Park as we walked by the side of the River Medway.

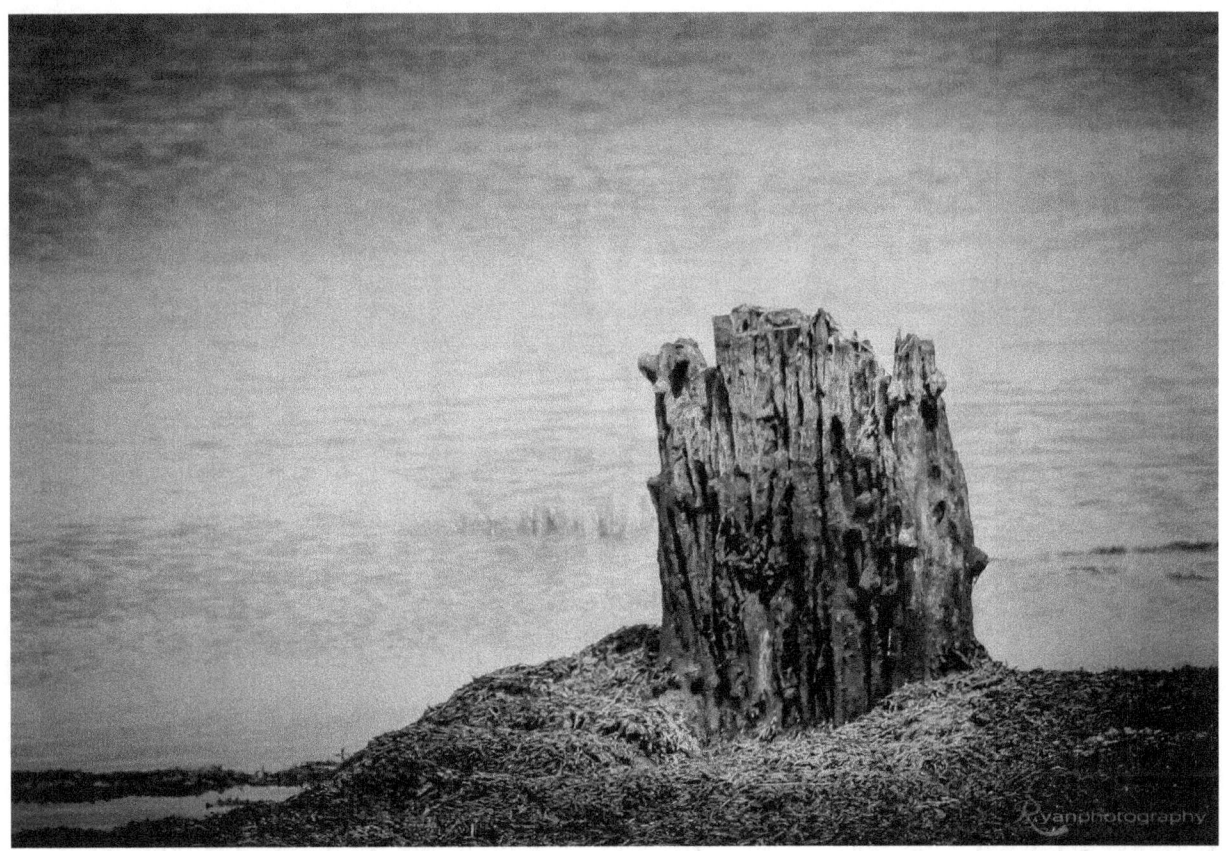

What attracted me to this particular photograph was the pure simplicity of it.. A photograph doesn't have to be crammed pack full of content for it to be special... The above photograph shows how little, is actually more.

It just looked like that driftwood was growing from the seabed.

And that particular photograph was created by the Rule of Thirds Composition method.

> *The guideline proposes that an image should be imagined as divided into nine equal parts by two equally-spaced horizontal lines and two equally-spaced vertical lines, and that important compositional elements should be placed along these lines or their intersections.*

The Rule of Thirds is used a lot in photography... but sometimes it is perfectly OK to break this rule. It just depends on the type of shot and what you want to achieve. There is definitely no hard fast rule saying that a photograph that is not shot with the thirds rule applied is not of good composition.

The following two photographs were taken at Deal back in July 2012...just as we were learning about photography...

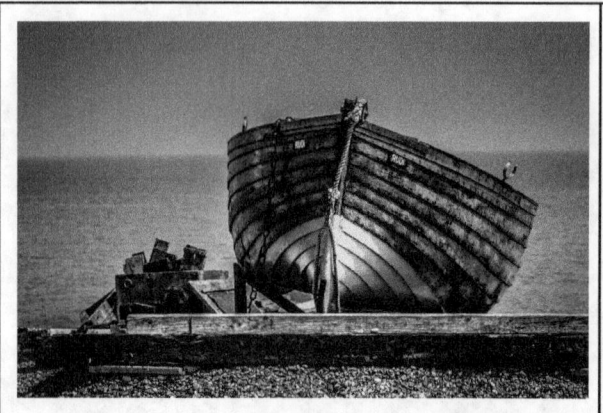

Looking back at those photographs... I really cringe now... as you can see we definitely had no idea of what we were doing... The composition is just totally wrong... there is absolutely nothing I like about those photographs. What in the world ever possessed us to think that rotten planks of wood were photogenic Yes the boat is sort of acceptable but wood ... no way. Especially wood that is just lying on a beach.

However one photograph that I do hold dear and it bring backs such wonderful memories is one we took back in September 2011 at Weymouth.. Even though it was taken with the Fuji FinePix camera... I do love the composition of this one...

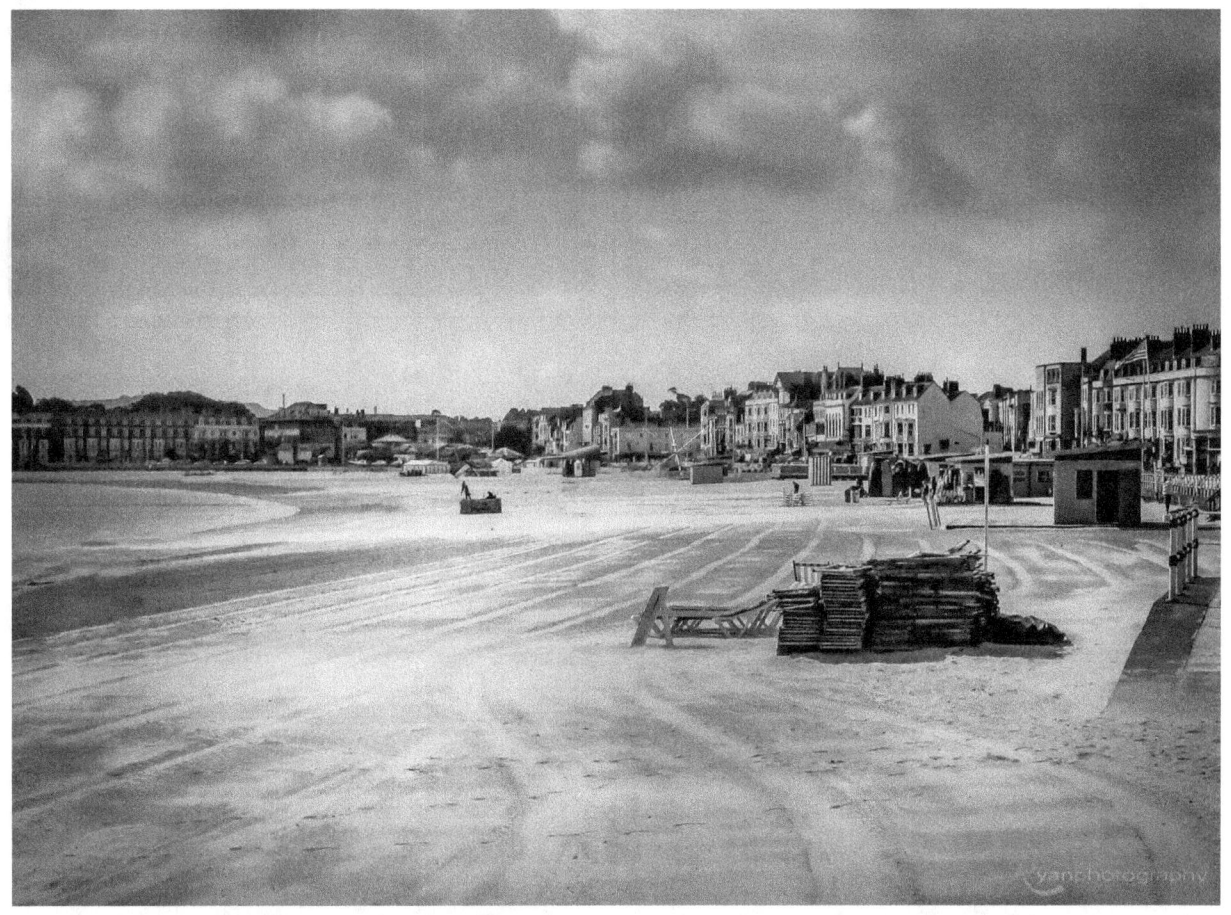

I love the sharpness of the buildings the lines in the sands and the deck-chairs stacked on the beach. I think that shot was a fluke and it was more luck than judgement.

In processing I have learnt to crop an image to get a better composition.. I have learnt how to remove distracting objects that add nothing to the photograph... I have learnt what a good photograph is and what bad one is..

These two photographs were a couple of years into our photography journey... when we were getting more confident... and beginning to understand what our cameras could do.

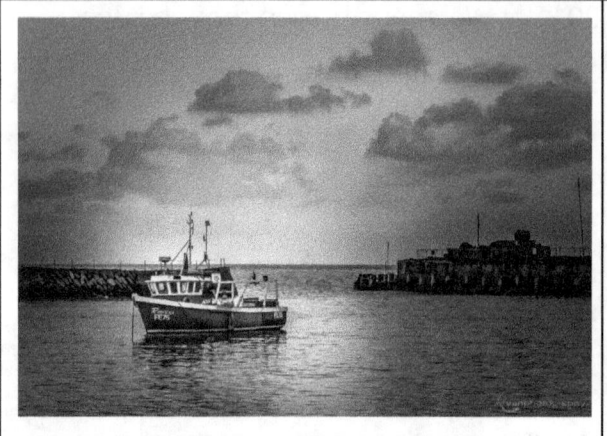 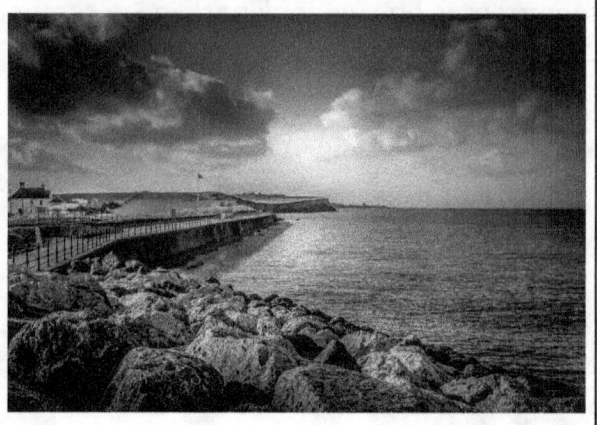

Seascapes are one of the hardest things to photograph in my opinion... you have to have the right conditions.. The right light and you definitely need drama in those skies...or a beautiful sunset. Without any of these you just end up with a snap of the seaside... and not a piece of art. And I love these shots of the Pacific Coastline with its rugged rocks and dramatic clouds.

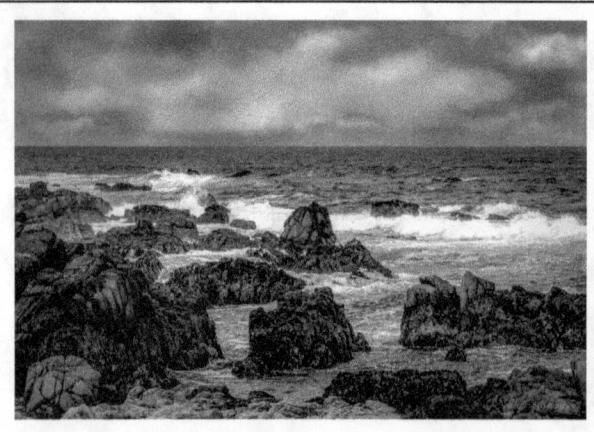 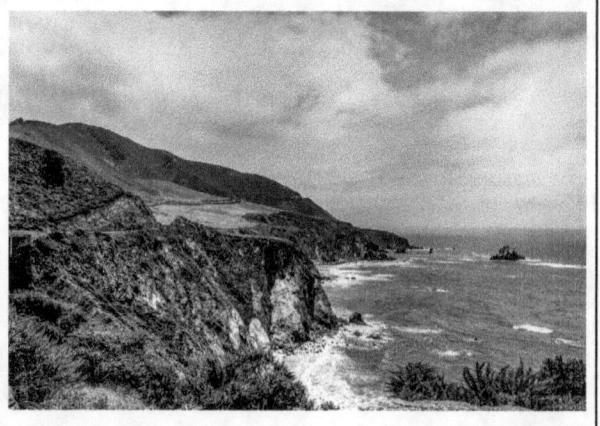

The first photograph on the left was taken in the USA from the coastline at 17-mile Drive and the second photograph on the right is of the Big Sur.. The American Pacific coastline is just one of those perfect locations to take photographs.

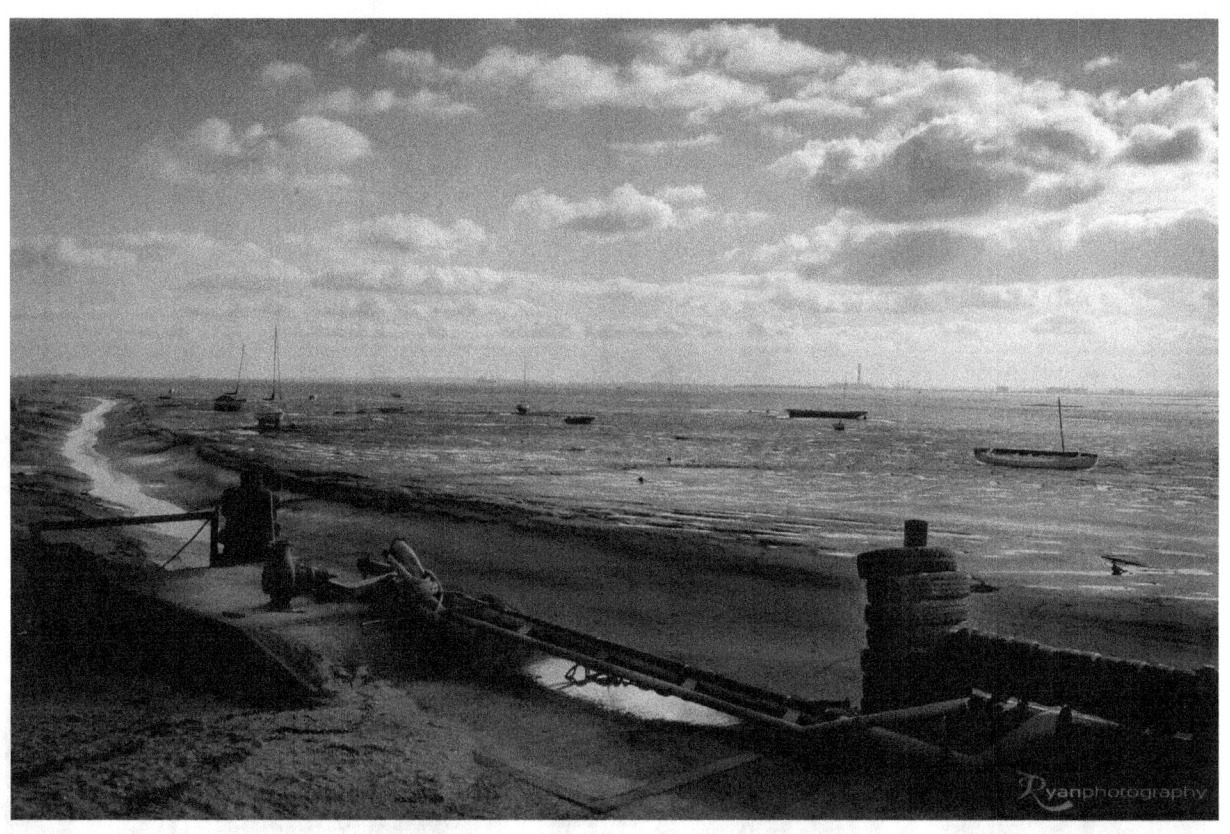

This photograph is of River Thames at Leigh-on Sea.. and the boats sitting in the Estuary.

Flowers and Trees

Flowers and trees are another great thing to capture... and one of my favourite photography subjects... With their vibrant colours and delicate petals they are a photographer's delight... However, on saying that, they are one of the hardest things to turn into monochrome.

The following photograph was taken at the beginning of spring.. Just as the trees started to get their new leaves. What we love about this particular photograph is simply the way the sun twinkles between the branches.

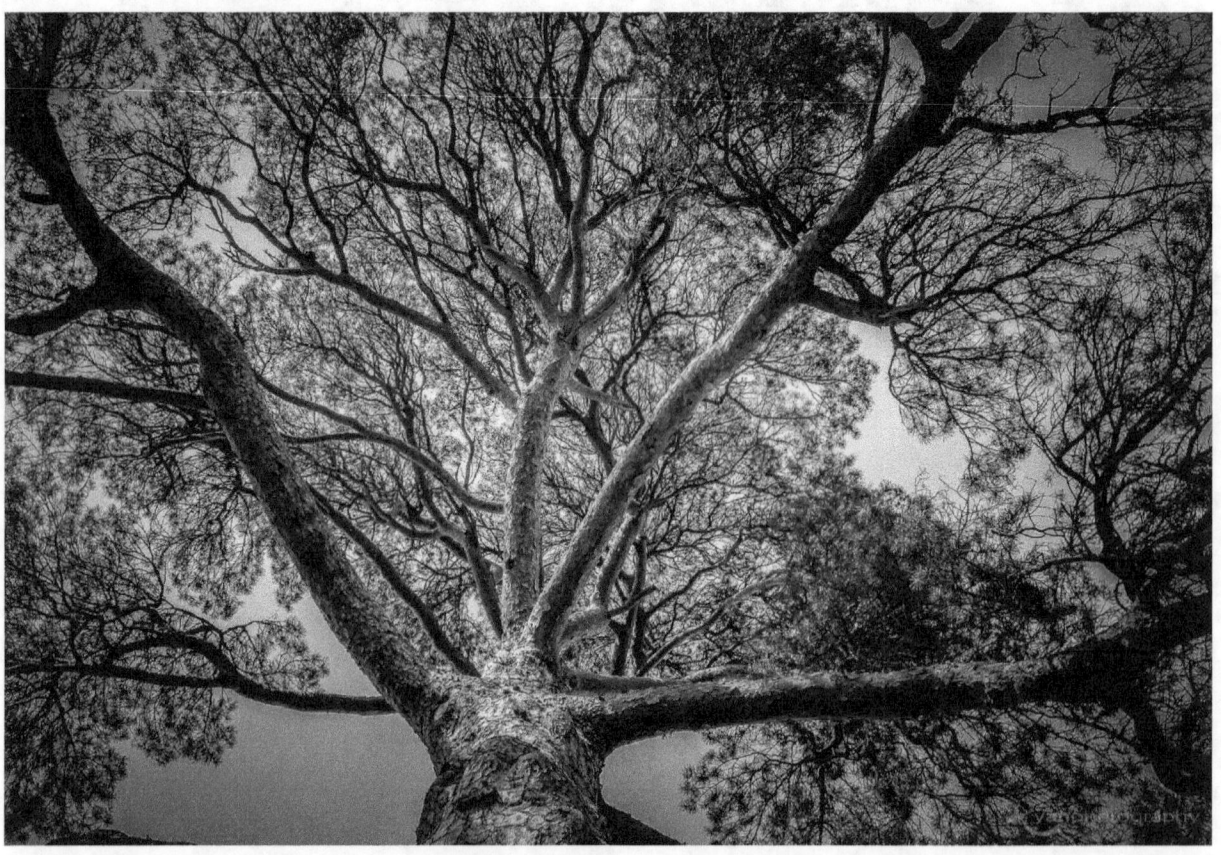

It was shot at one of our favourite places to visit.. Somewhere local to us called Ightham Mote near Sevenoaks in Kent. As we are from Kent we have visited Ightham Mote on several occasions and each visit has been pleasurable... you can really see the seasons

change throughout the grounds and the surrounding woodland. Surrounding the house is a Mote and to enter and exit the house you have to go over a little bridge..

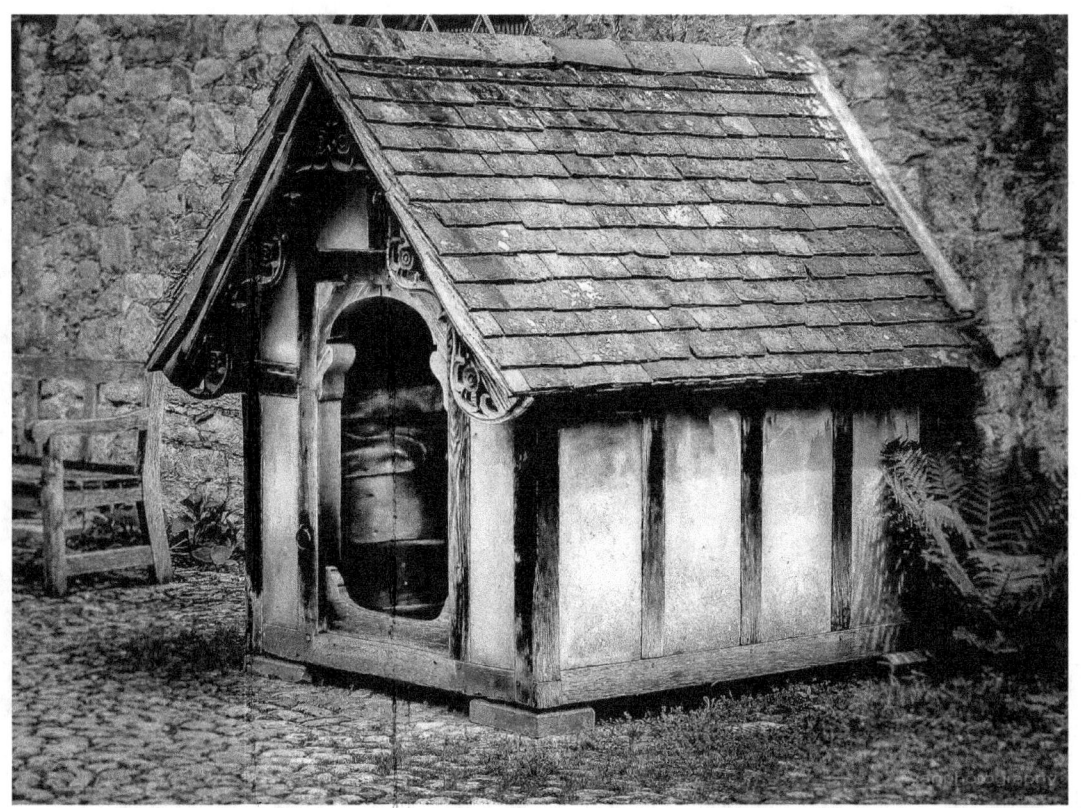

There is a courtyard in the centre and within this courtyard there is a dog's kennel. It was built back in the 19th century for a Saint Bernard named Dido, and this dog house is the only Grade 1 listed dog's house.

If you like to photograph flowers then Ightham Mote also had gardens and some lovely flower beds... On a nice summer's day there is a huge lawn on the north side of the house where you can picnic and relax.

The following photograph was taken back in May 2015 at Yosemite National Park in the United States of America.. What I love about this particular photograph is the contrast between the trees and the sky... It was shot facing the sun..but luckily I didn't get much sun-flare and what I did get.. to me enhanced the photograph.

If ever you are on the West Coast of America then you really do have to visit Yosemite National Park... the scenery is stunning.. The mountain range is breath-taking and above all the ride up to Yosemite from Merced... is out of this world. The River Merced runs parallel with the main road to Yosemite.. And the cascading water running down the River Merced is absolutely stunning.

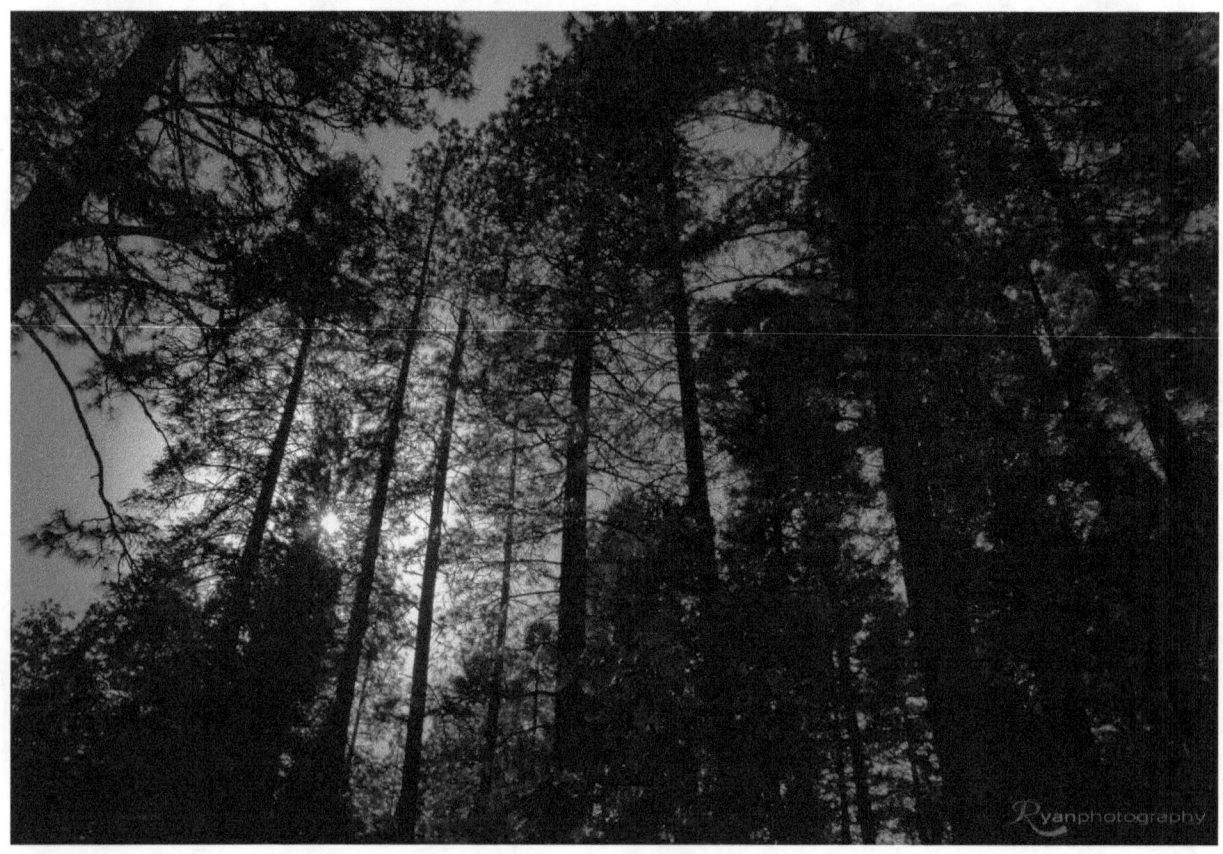

Yosemite has such beautiful trees... there are wonderful views and a lot of the photographs to take, and the ones we took at Yosemite I decided to process them mainly in Monochrome. Whether Yosemite bought out the Ansel Adams in me... I don't know... but I was truly inspired when I visited an exhibition of his works many years ago at the Greenwich Maritime Museum in London.

We just couldn't help ourselves at Yosemite to take loads of photograph... and we were totally in awe of the beautiful scenery that surround you.. Our tour guide had arranged

for us to have a trip around the valley floor. By luck our Yosemite Guide Ranger stopped at some beautiful locations where we could capture the breath-taking views within Yosemite, with its large mountains, pine trees and stone bridges.

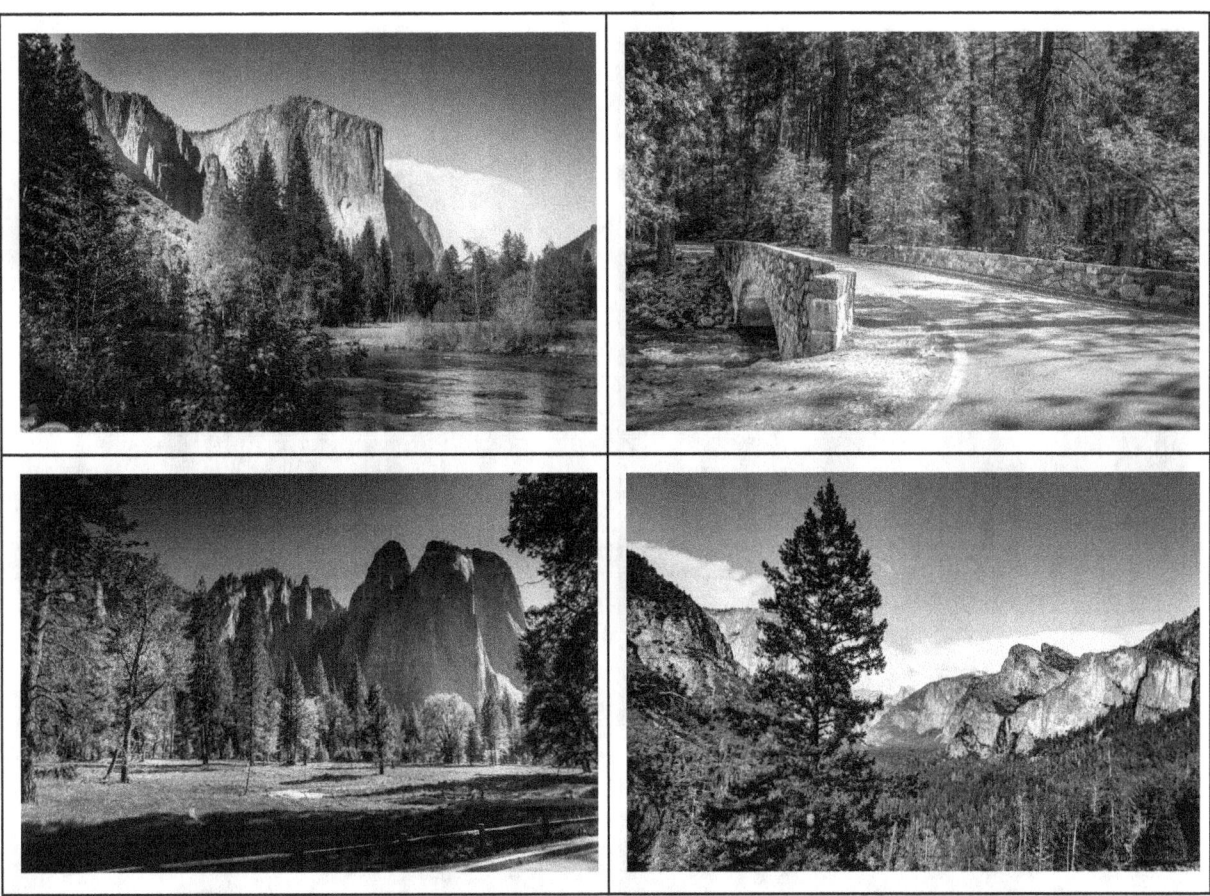

As I said earlier on in this chapter photographing flowers and turning them into black and white photographs can be slightly tricky... sometimes the conversion works sometimes it doesn't. But that is the beauty of Lightroom.. You can experiment if you don't like the monochrome version.. Then change it back to colour.. But sometimes the monochrome version to me... can enhance an image. It can give a photograph a whole new depth and meaning.

But as I said finding that image can be a little tricky.. But over time you will look at a photograph and just know when it should be black and white.. Your instinct just screams at you to convert a photograph into black and white and normally your instincts are right.

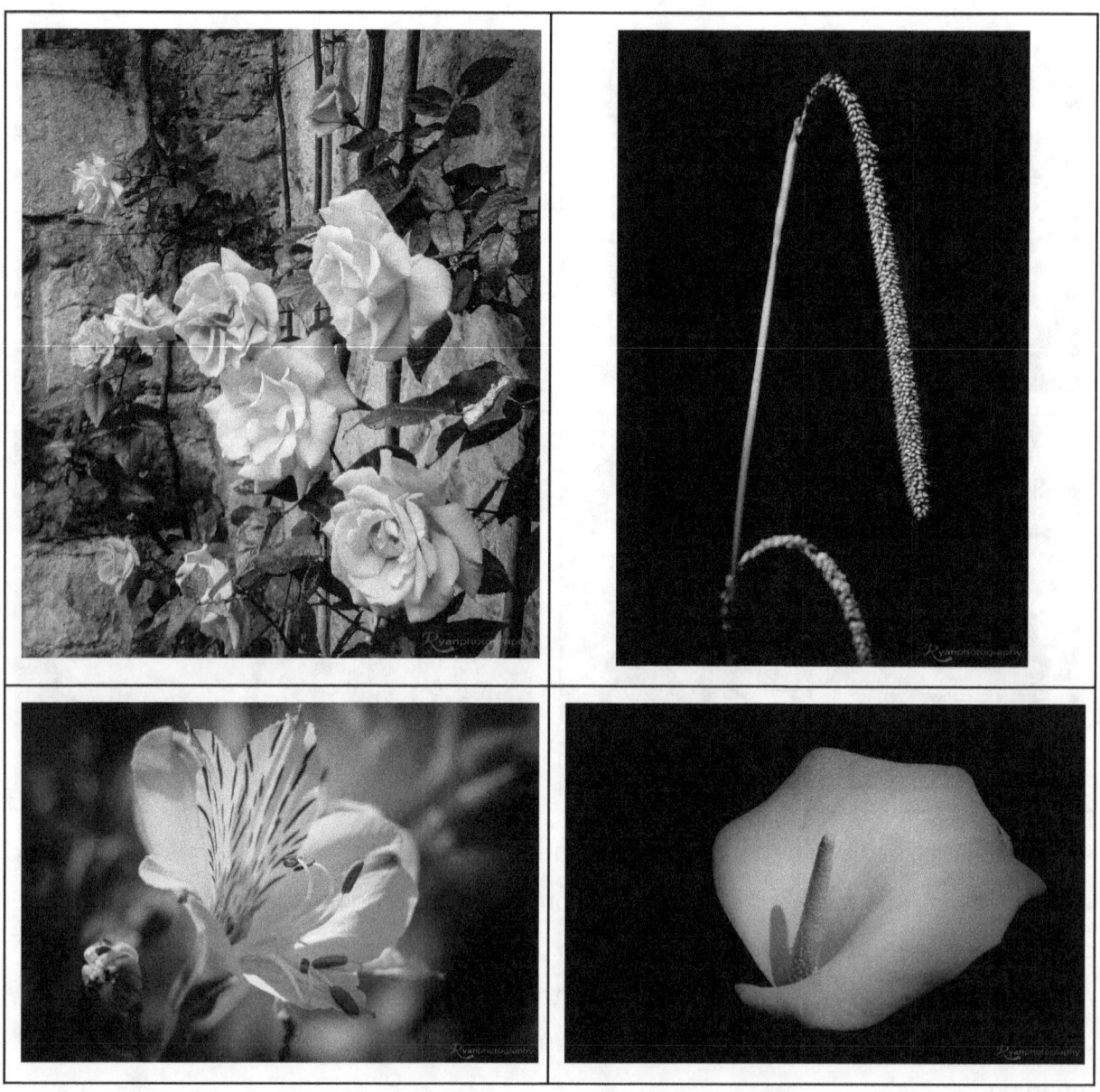

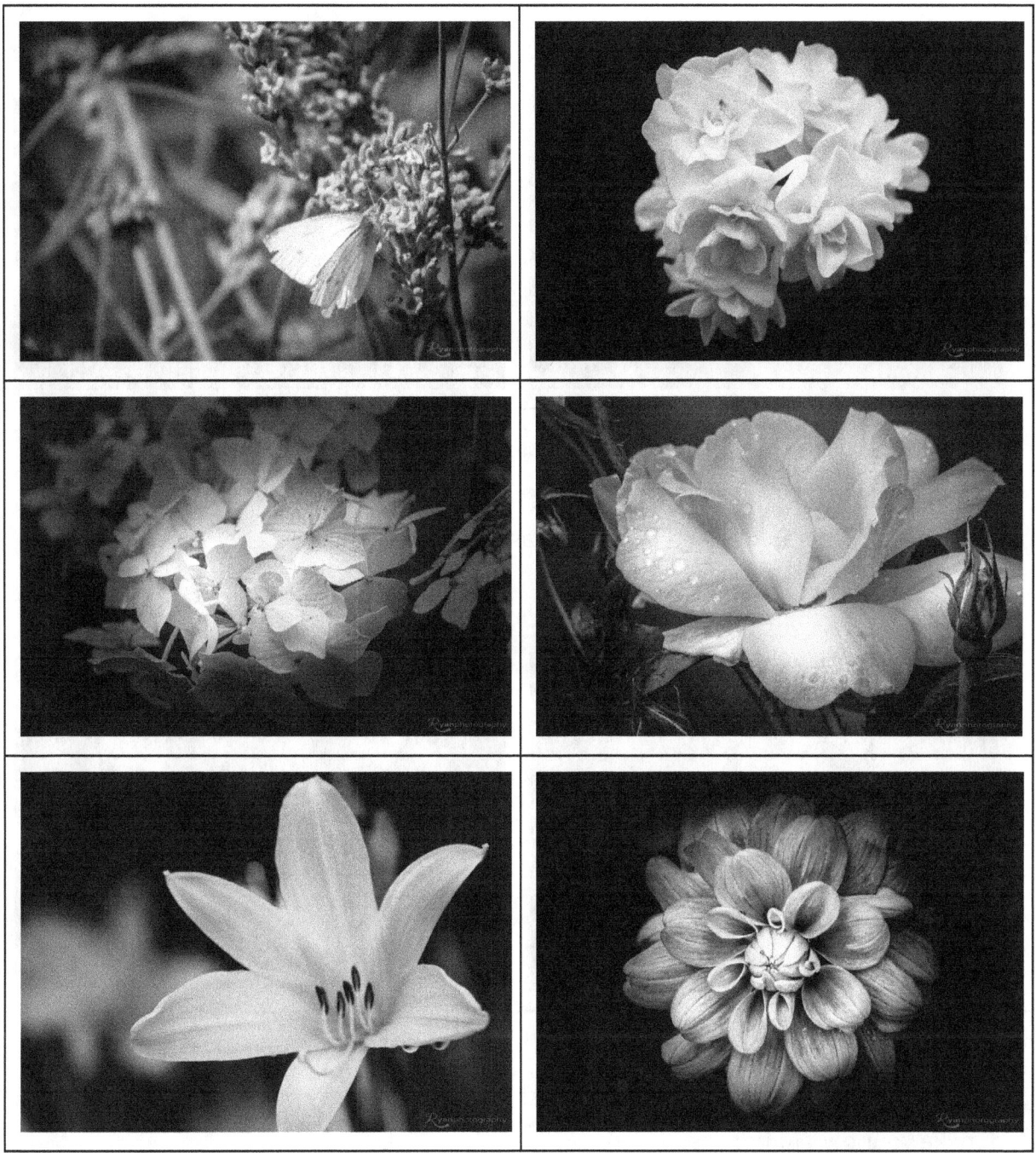

Monochrome photography isn't just about an image being black and white... for instance the image on the bottom left is actually a monochrome image with a blue tint.

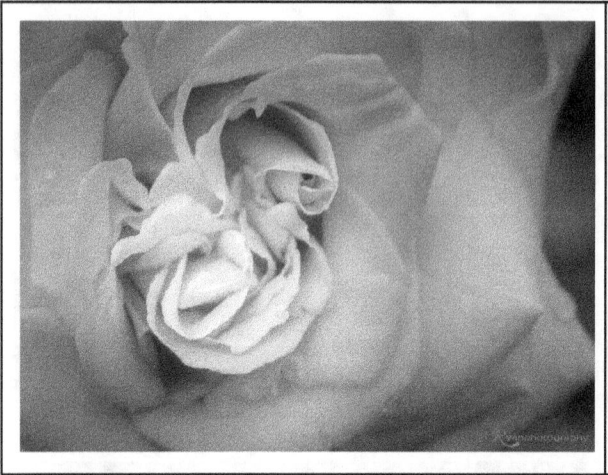 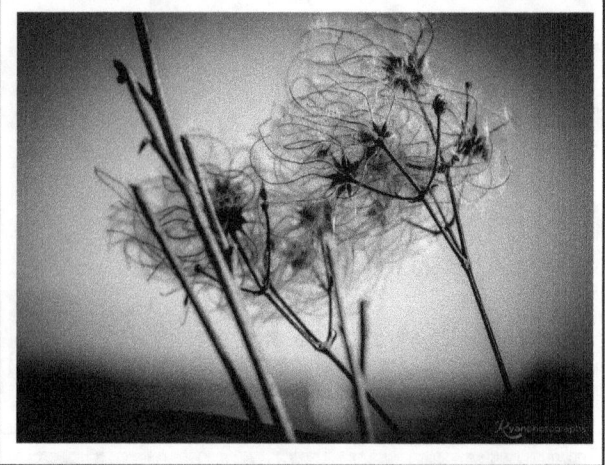

Whether it is a rose with raindrops on it or old man's beard your imagination is the only thing stopping you from creating a stunning piece of artwork... I have actually had the old man's beard photograph turned into a canvas print which hangs on my wall.

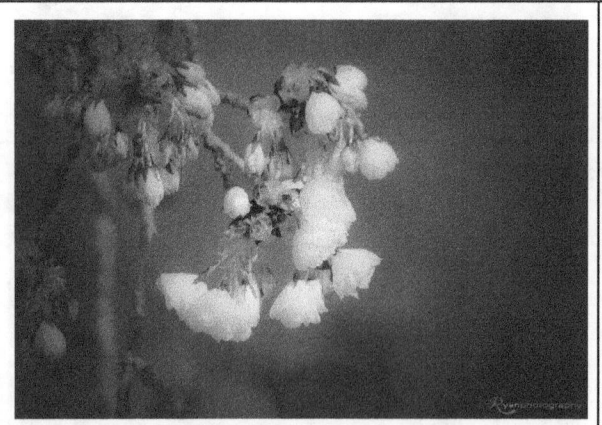 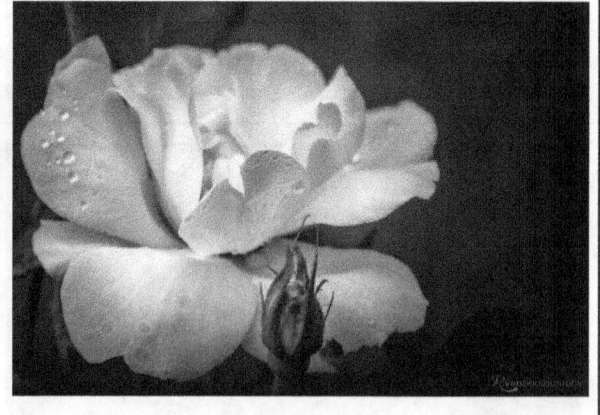

And I don't know about you..but I think raindrops on a flower's petals enhances floral photography. And if you don't get rain whilst out... take a spray bottle of water with you... and make your own raindrops.

Architectural Places

Wherever you may travel or however far, just around the corner there is a perfect photograph waiting for you to capture it. Look at architecture of buildings, look for character, look at things that you would normally just glance at... because even a mundane thing can be turned into a piece of art with a change of angle when photographing the subject.

For as long as I have lived, we have travelled over Rochester Bridge, in our hometown and never did it cross our minds to photograph that bridge.. That bridge to us was something that took us from A to B and back again. It was just a bridge over the River Medway.. But that bridge is steeped in architecture when you take a closer look at it.

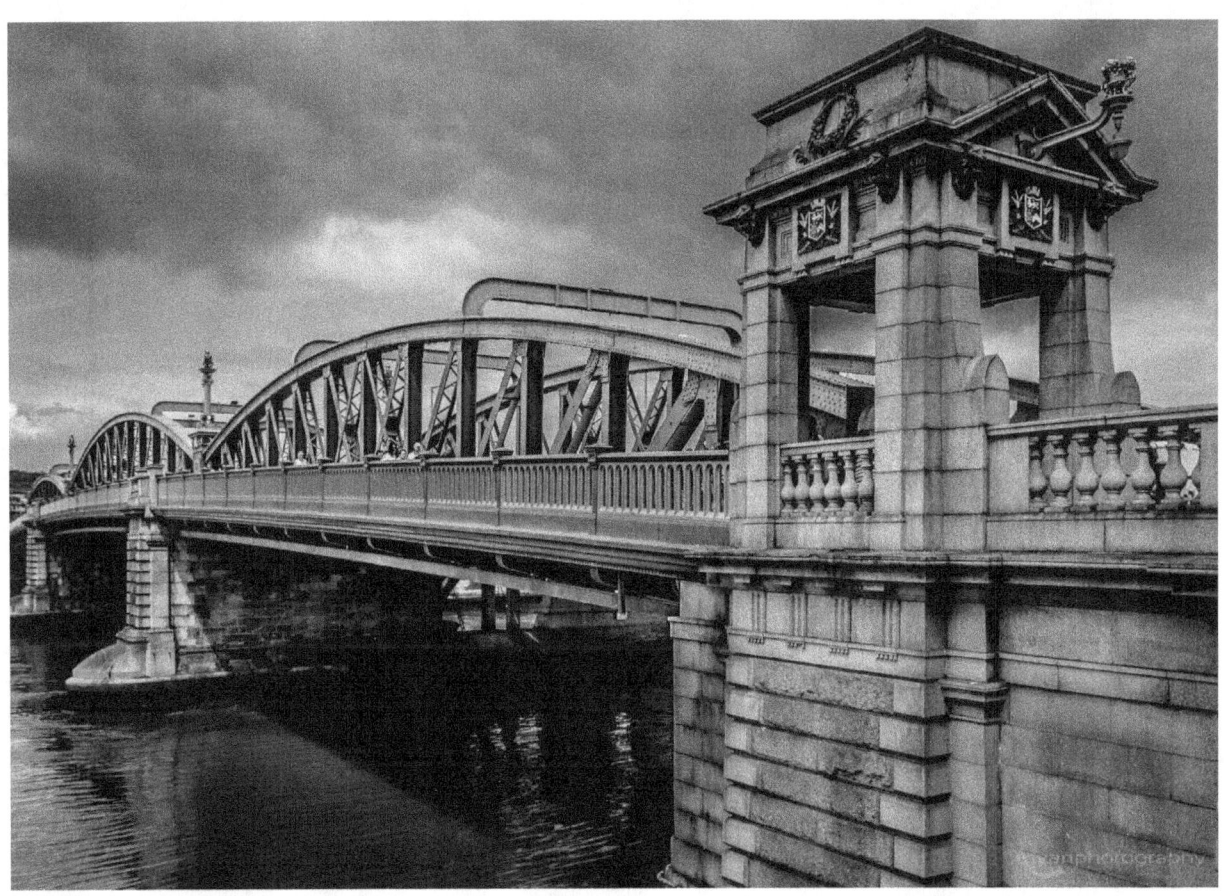

The concrete pillars and railings as well as the ironwork that spans the bridge. So much character and charm to that bridge.. Something we both have ignored for years.

The above photograph was taken on one of our trips to Rochester and was taken on the Rochester side of the bridge... What I love about that particular photograph is the textures and tones of the bridge.

But we were in luck that day.. Simply because, normally there is a bus, a lorry or some other high-sided thing that obscures the bridge but patience that day paid off. We were able to photograph that bridge without one of these things passing over it. I suppose the traffic lights helped a little when they turned red and the main traffic on the A2 had to stop. And those concrete railings helped in obscuring any cars that were travelling over the bridge.

There is architecture all around you... look at chimneys... rooftops... look at houses

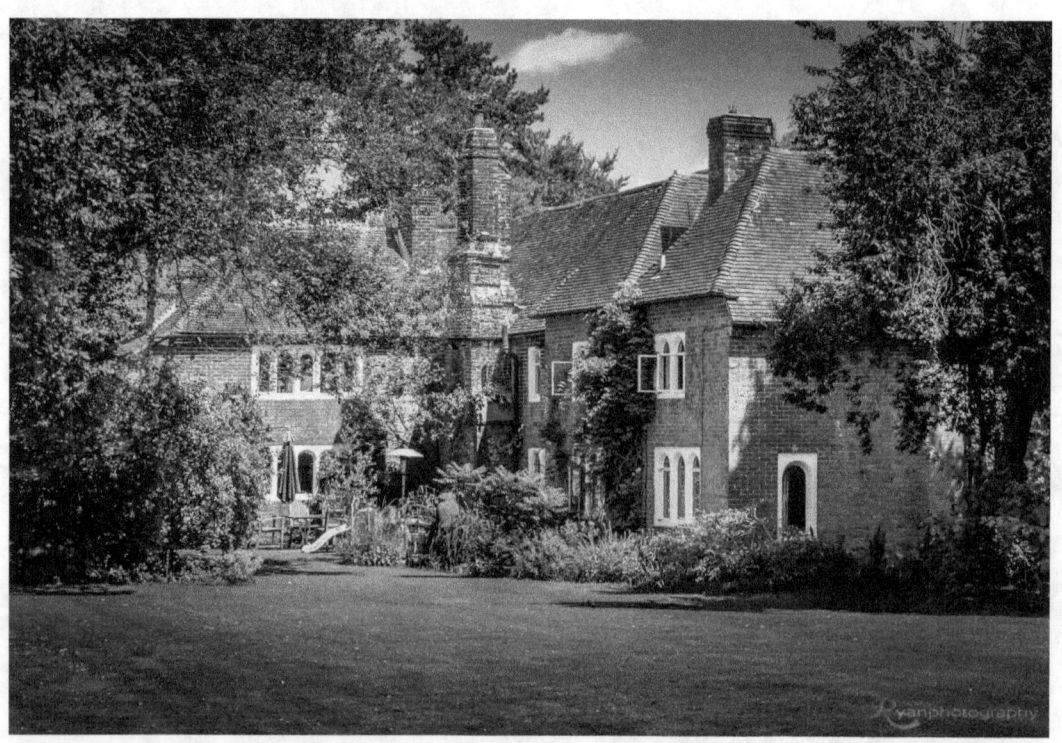

This is a photograph of the house at Beech Court Gardens in Challock, Kent.

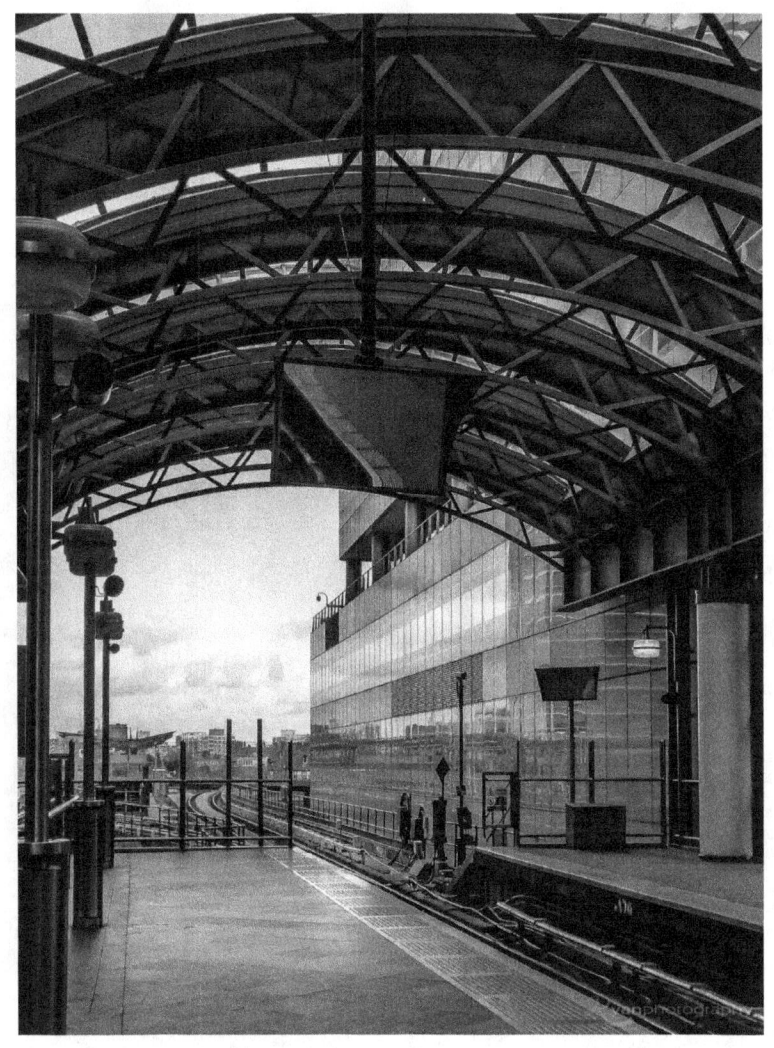

Even a DLR train station can produce a wonderful shot... The above photograph was taken at Canary Wharf DLR station as we waited for the DLR to take us to Crossharbour in London. And once again, by luck, a train had just left the station and we managed to capture this shot without any passengers waiting on the platform. Sometimes in photography that perfect shot just needs a whole lot of patience. Patience whilst waiting for people to move, patience whilst waiting for the right light... patience whilst waiting for boring clouds to pass on by..

Honestly you can't believe the amount of times we have lined up the perfect shot.. Got the composition spot on and then someone decides to walk into the frame. You smile

politely but inside you think to yourself... what a price plum they are.. I know people have the right of way.. But now if I see someone taking a photograph.. I stand back until they give me the nod that they have captured their shot and it is OK to walk on by. I now understand how frustrating people can be to photographers... unless you are a street photographer of course.

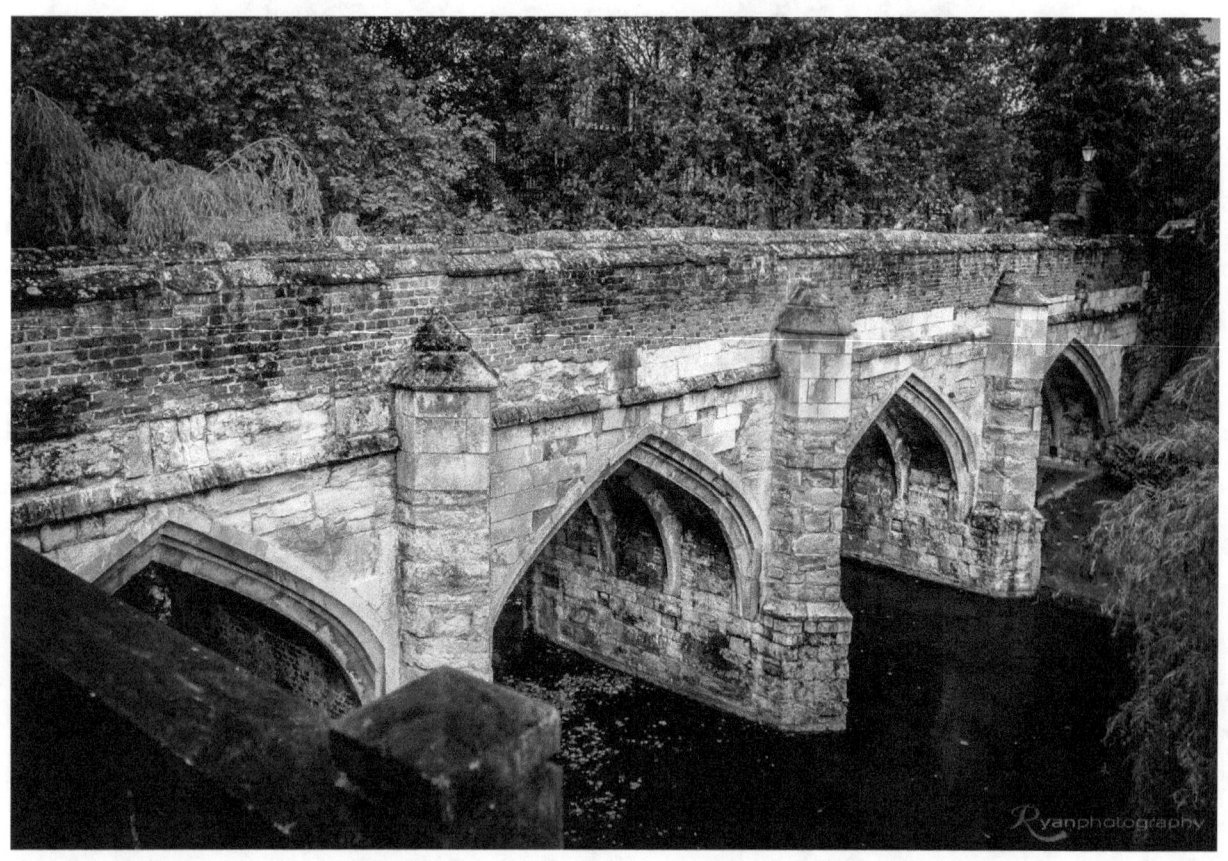

Another bridge that we photographed was the bridge that spans the moat at Eltham Palace Gardens in London. Again that photograph was one of those photographs were you needed a whole lot of patience.. Waiting and waiting some more because there were people hanging over the bridge looking down into the moat. But I managed it eventually

Architecture is everywhere... whether it be old buildings or new buildings... each building and place has its own architectural importance. I love photographing castles and historic buildings but landscapes and flowers are my forte.

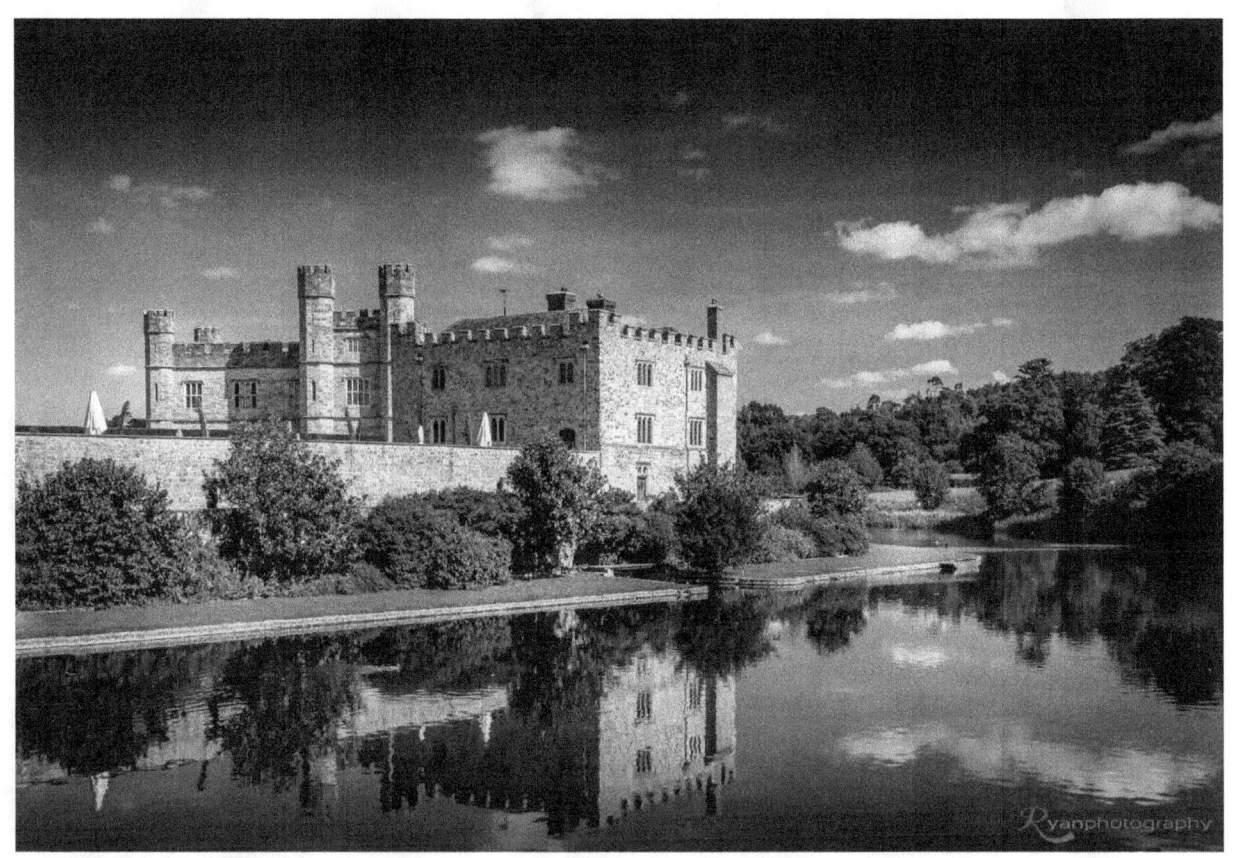

The above photograph is of Leeds Castle near Maidstone in Kent.. the grounds are spectacular and there is so much there to photograph.. There are landscapes, architecture wildlife.. You name it, and it is there.

Castles also have so much architecture attached to them.. Take for instance Walmer Castle in Kent. Walmer Castle is not too far from Deal Castle… and of course that gives you the perfect opportunity to visit both castles in one visit to the South Coast.

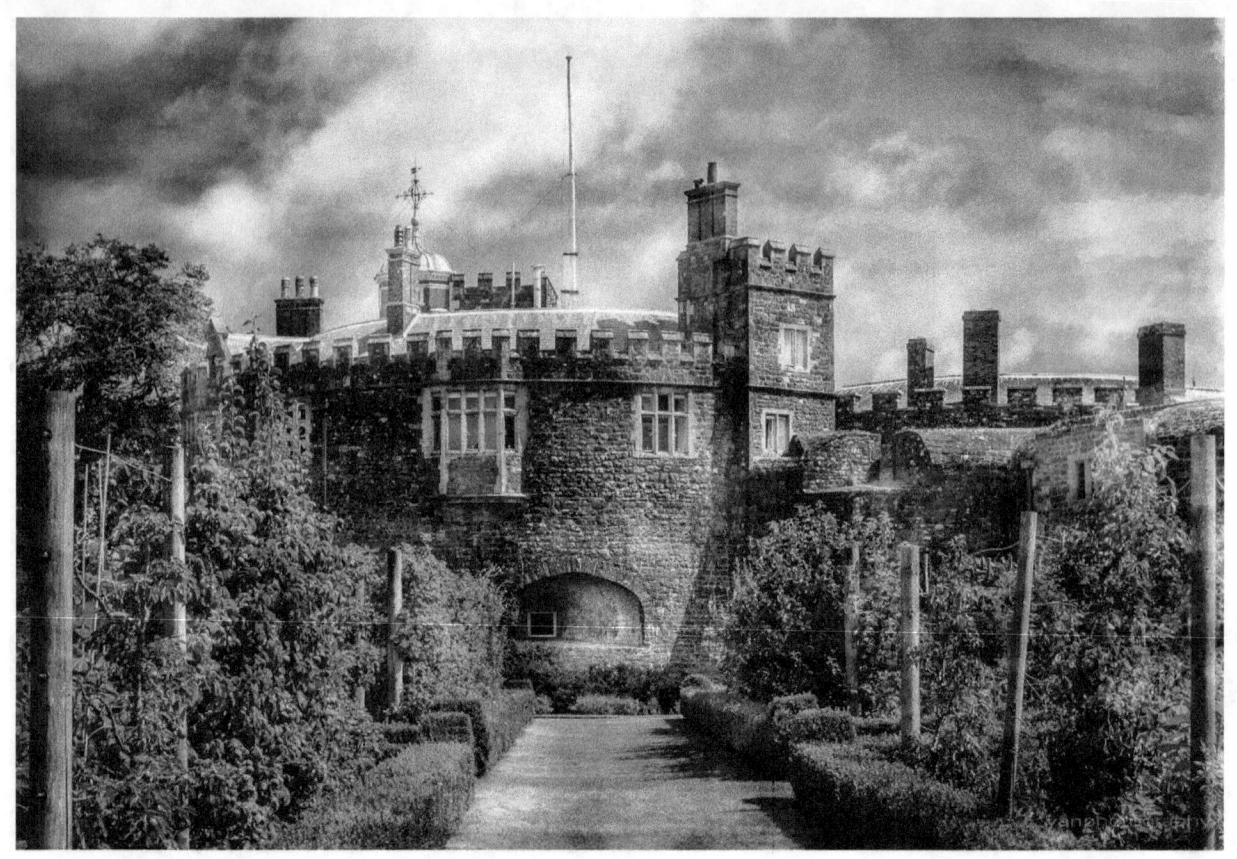

Walmer Castle is on the South East Coast not far from Deal.. and it has gardens, as well as woodland walks... From the top of the castle you can overlook the English Channel. But architecture doesn't have to be old and antiquated. It can be new buildings... it can be full of high rise buildings..

Take for instance this shot of Canary Wharf.. Taken from North Greenwich embankment looking over towards Canary Wharf.

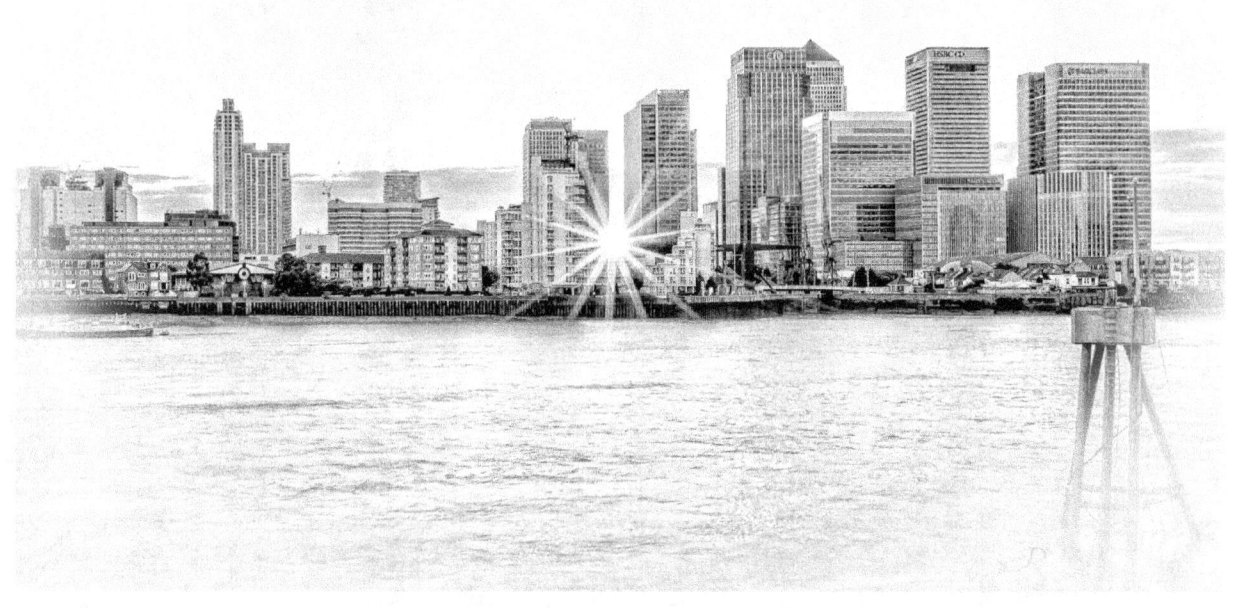

On that particular day the photography requisite was to capture the lights of the buildings as darkness descends... We arrived at North Greenwich just as the sun was setting.. And that was one of the very first locations we visited to try out Night Photography.. Night Photography is something we are still learning today.. Unfortunately we are rather lazy when it comes to taking ourselves off of the sofa and out to find a sunset. Plus I have problems walking so by the end of the day... I just want to put my feet up and relax.

Architecture is all around us... it comes in many shapes and forms... and it can be the old mixing with the new... take for instance buildings in Greenwich... This photograph was taken of the Old Military Hospital and in the background of the photograph, just across the river; you see the new buildings of Canary Wharf.

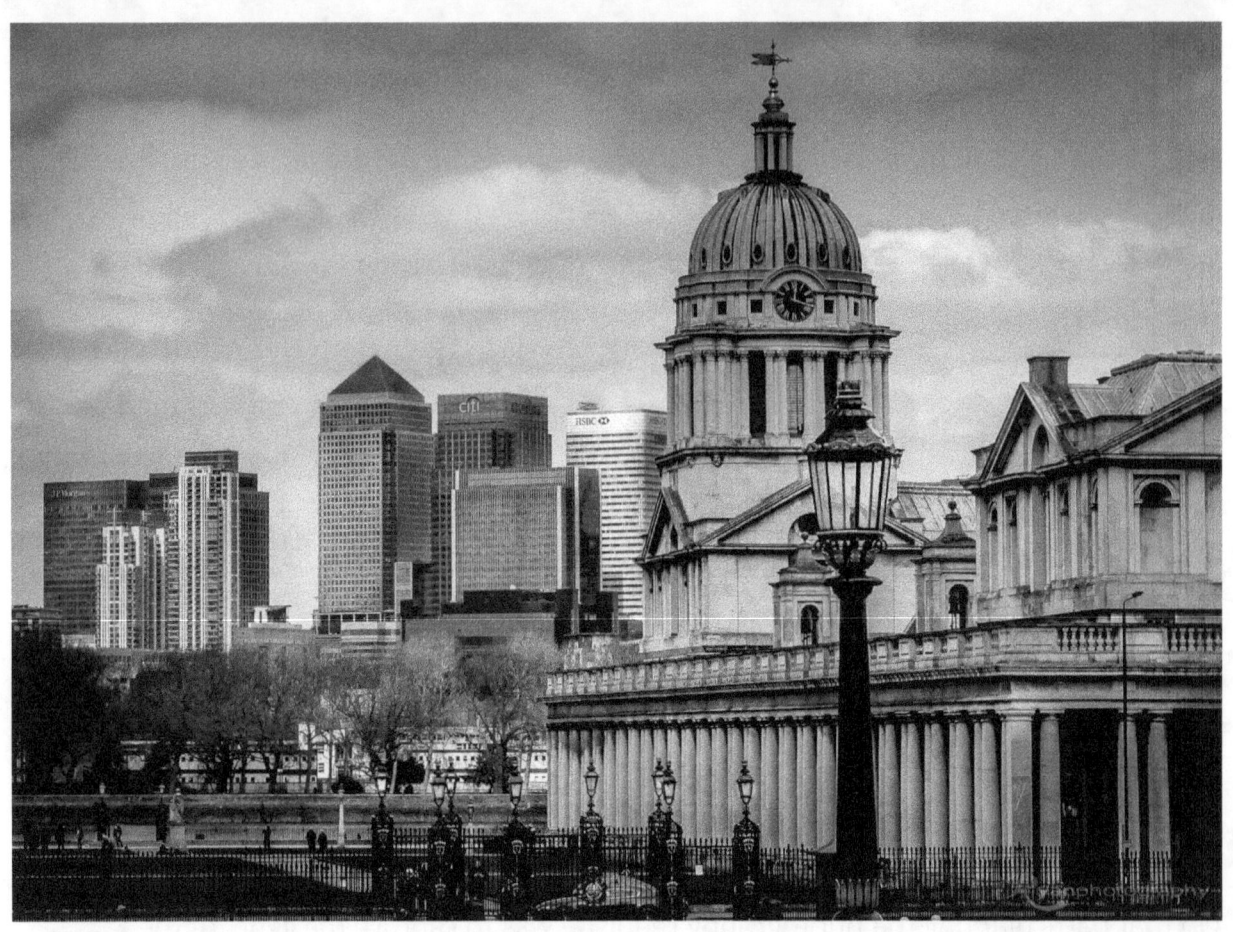

London is one of the best places to photograph architecture. The only problem we have is this... he works in London and the last thing he wants to do on a weekend is travel back into town.. which I can fully understand. I don't think I would like to work there and then have to go back there to take photographs. But honestly there is so much architecture of different eras.. You could literally spend all day and night just travelling around taking photographs of landmarks.

Just a piece of useless information but do you know when the best time to photograph London is? A time when the streets are deserted! Well it happens to be early on Christmas morning... London then is quite deserted.

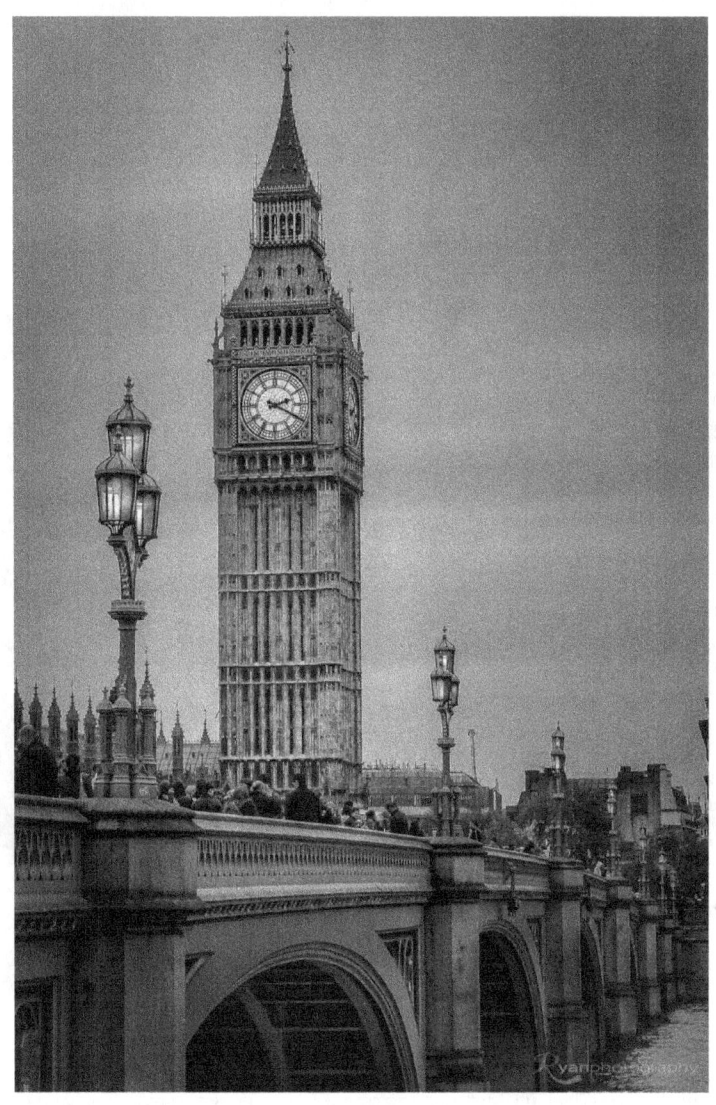

The above photograph is of Westminster bridge on Saturday afternoon... it is crowded and it was taken in mid-winter. You can see the masses of people walking over the bridge.. Many of those people were heading towards the London Eye... Now I went on the London Eye but never again.. Firstly I don't do heights and secondly the price ...

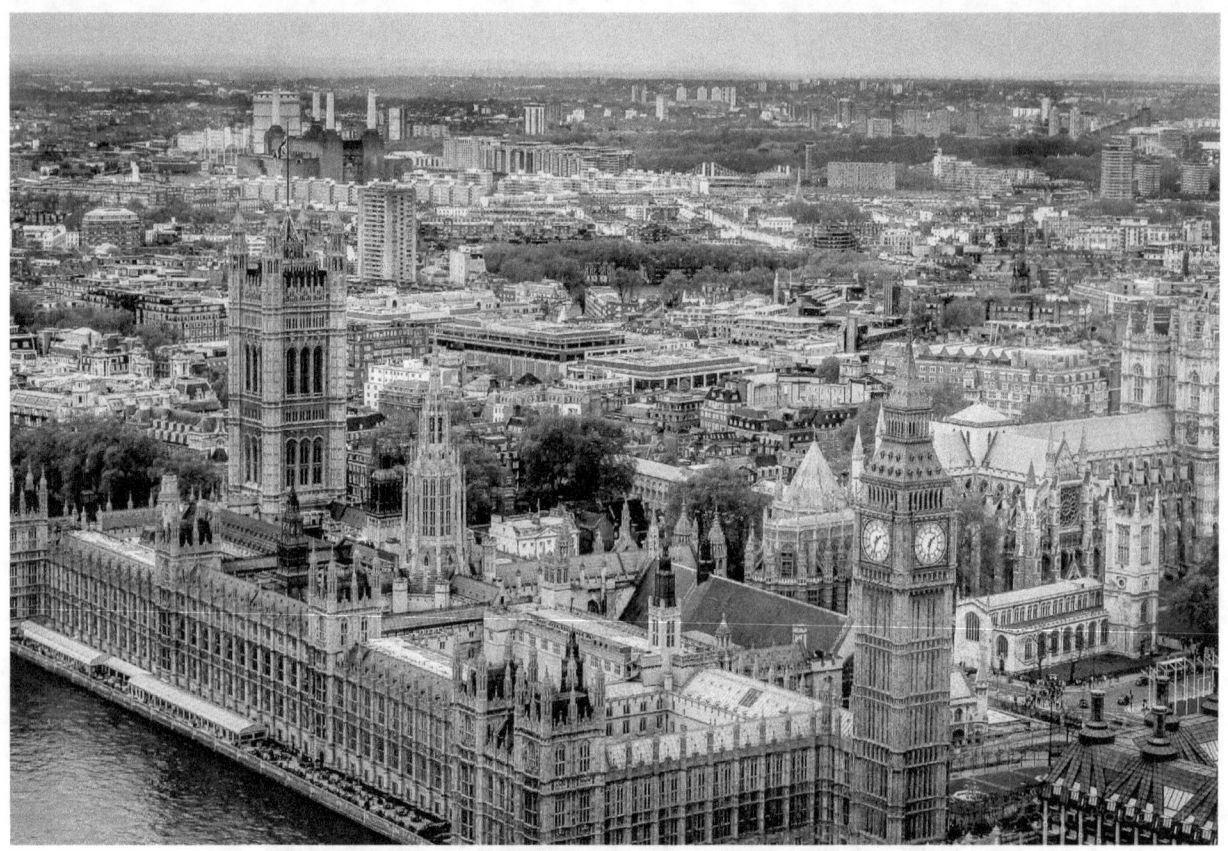

The above is a photograph that was taken of Westminster and the Houses of Parliament was taken from a ride on the London Eye.. You can see for miles… and I was so glad when that London Eye trip ended.

Architecture can even be found in local streets.. One particular location is Upnor High Street. With its two pubs and cobble-stoned street.. And it is worth visiting and at the bottom of the High Street is the River Medway and Upnor Castle.

On the next page are two pictures one of Upnor High Street looking up towards the top of the street and the other looking down towards the river.

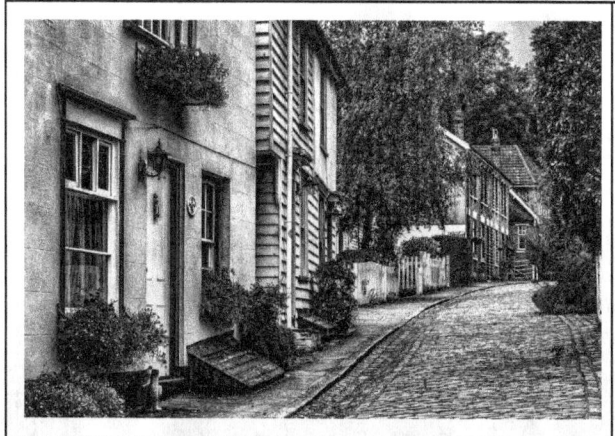 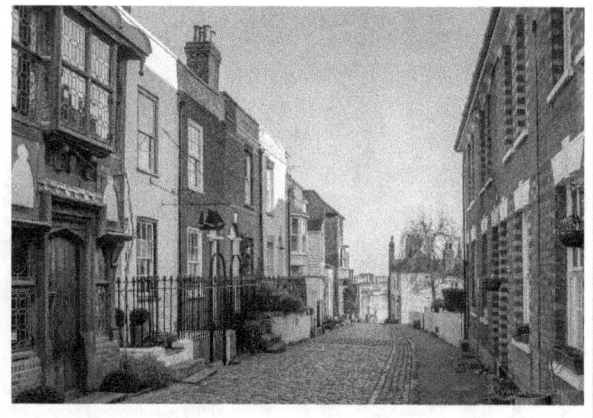

With regards to the photograph on the left... I wanted to process this photograph with a grungy look and to achieve this I used a plugin from Topaz Labs called Topaz Adjust.

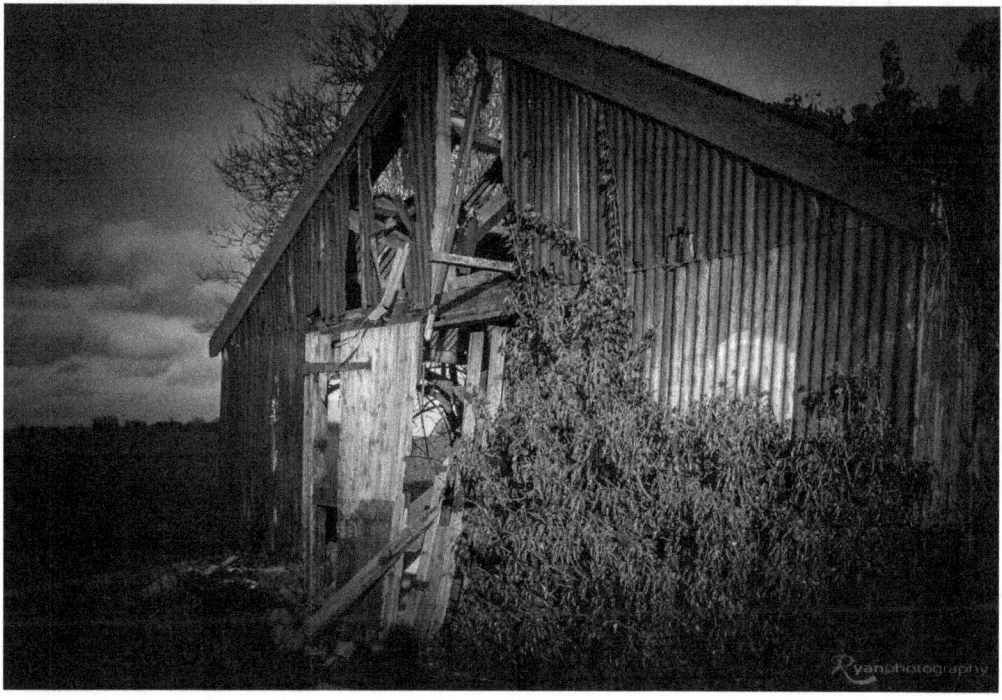

Even old barns have architectural elements to them.. Ruins and castles are in abundance here in the South East as well as a lot of castles.

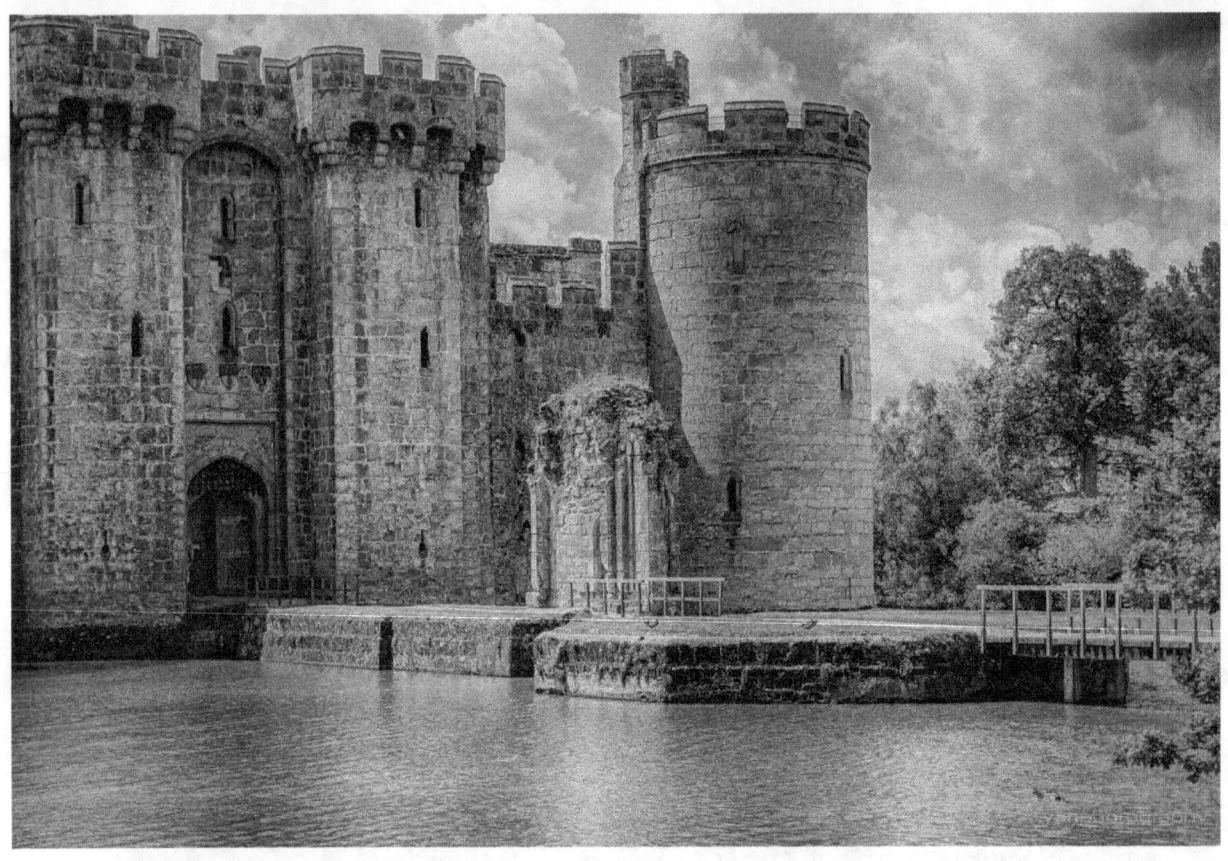

The above photograph is of Bodiam Castle in East Sussex... not far from the castle is Bodiam station where you can get a steam train to Tenterden... we have been on that rail journey and it is beautiful.

Whether it be a building, a ransacked barn, you see architecture everywhere... Like the photograph on the next page.. It is a stone-arch at Scotney Castle in Kent. Scotney Castle situated on the A21 near Lamberhurst is a beautiful place to visit. It is owned and maintained by the National Trust and what I love about Scotney Castle is that they allow you to take photographs within the main house... albeit without a flash.

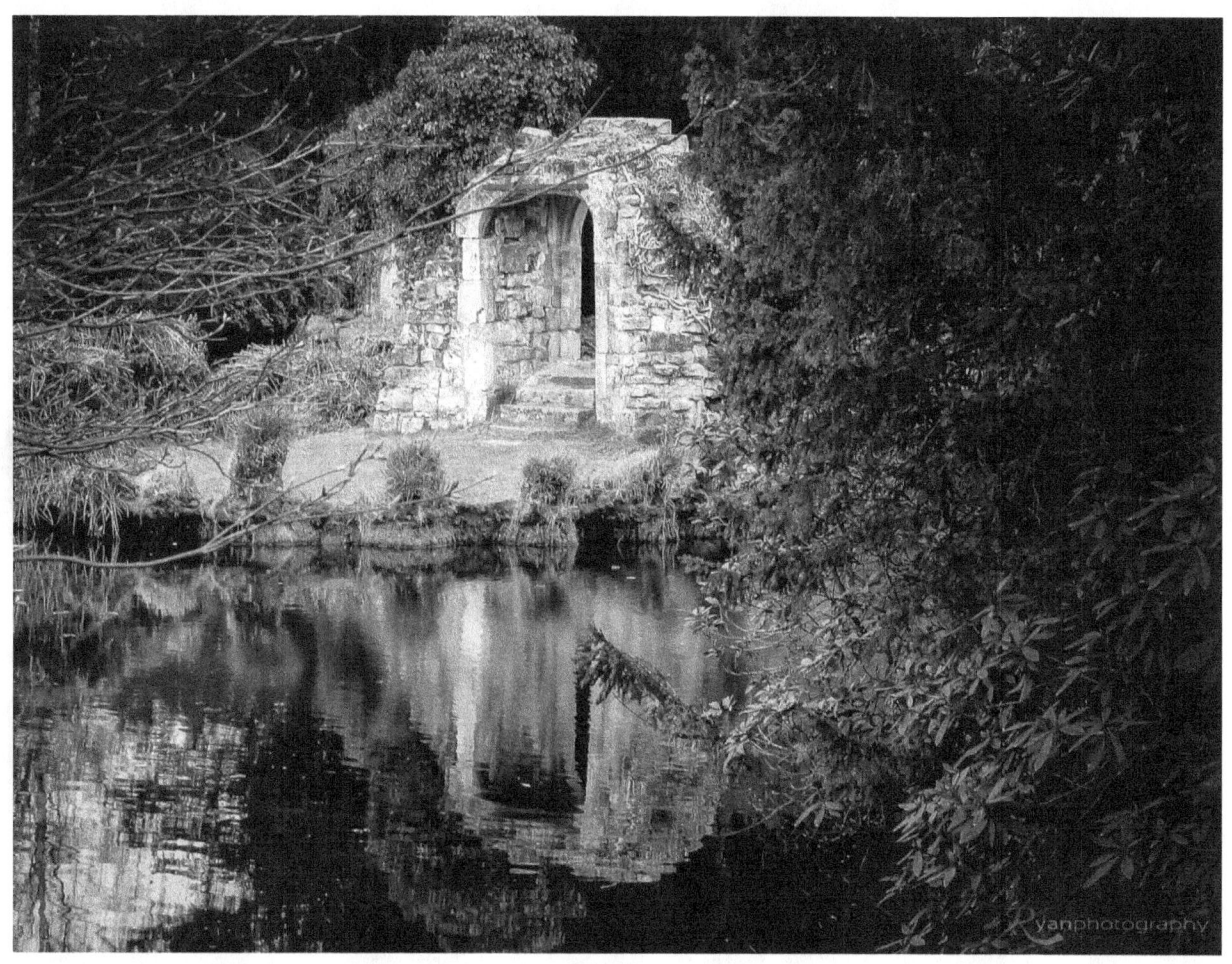

I just love the reflection of the arch in the water. There is something about reflections and if I get the chance to photograph a subject with a reflection I will, especially if it shows up the architecture of a building... like in the Leeds Castle photograph earlier on in this book.

One thing I do have to say is this... when I first started out on my photography journey.. I didn't see reflections.. And I definitely didn't see how they can add something special to a photograph. They add charm and character. Now, when photographing a subject near water... I look not just at what I am photographing but whether there is a reflection.. And primarily whether I can use that reflection to its full potential.

Take for instance this photograph... it is a panoramic of Leeds Castle.. And I just love the reflection in this photograph.

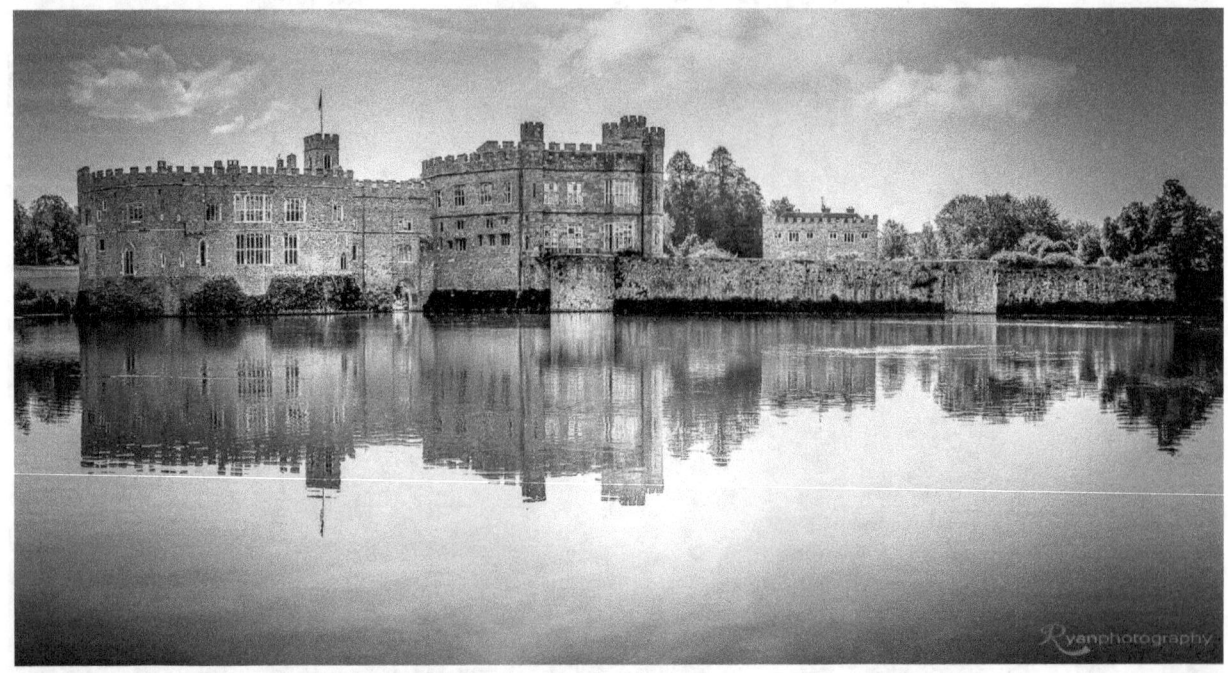

It just looks like a mirrored image of the castle... Even ripples in the water add to the reflection.. So now when photographing anything near water.. My eye just looks for that reflection.

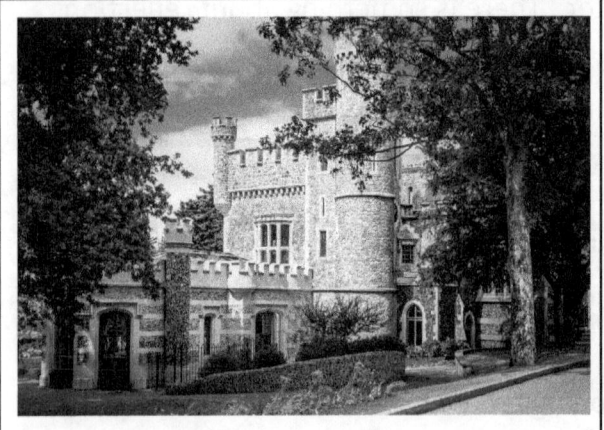

The photographs on the previous page are Whitstable Castle and the courtyard at Belmont House and Gardens in Kent.

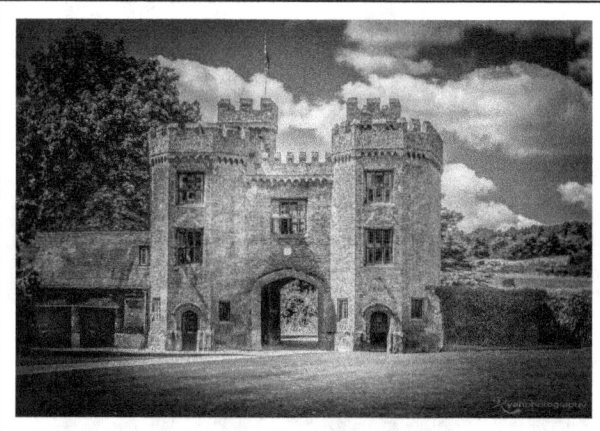 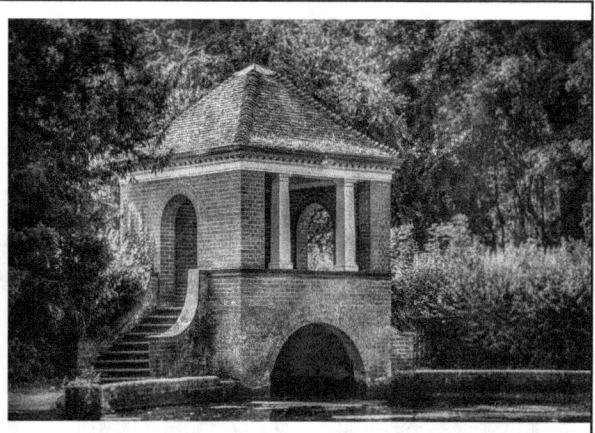

The photograph on the left is the gatehouse at Lullingstone Castle, near Eynsford in Kent and the photograph of the right is one of the three ornamental bridges that span the stream at Russell Gardens near Kearsney in Kent.

The photographs on the following page are also forms of architecture.. Both images were taken at Nymans House and Gardens in West Sussex... the left hand image is of the cottage that is located within the grounds of the estate and the image on the right is the Dovecote at Nymans.

Nymans is a wonderful place for architecture especially the ruins of the house... a disastrous fire in 1947 almost gutted the house.. And today the fire damage can still be seen in the roofless ruins that are just a shell of what they were.

Unfortunately Nymans also suffered terribly in the great storm of 1987 where a lot of trees were lost to the hurricane... and today it is slowly but surely springing back into life.

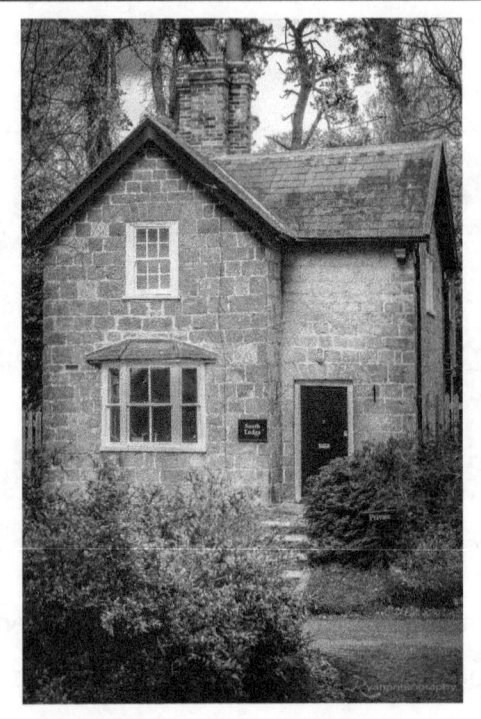
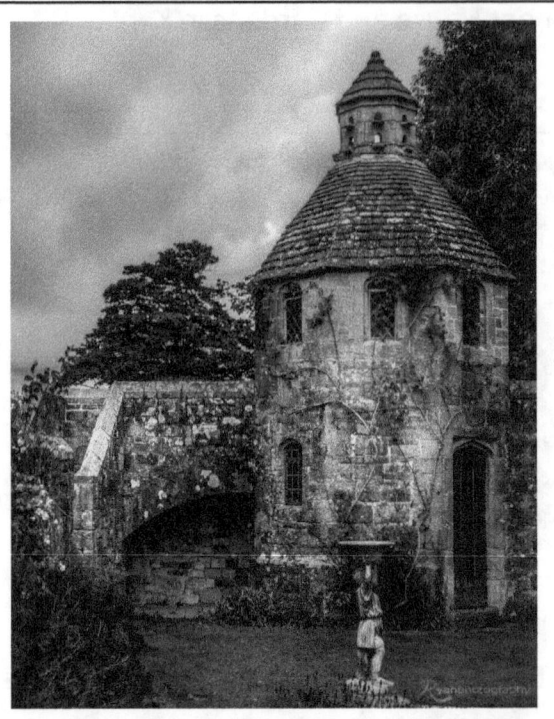

Below are another two examples of architecture... from Oast Houses at Great Dixter House and Gardens to the Palace of Fine Arts in San Francisco... architecture is everywhere... just waiting to be photographed.

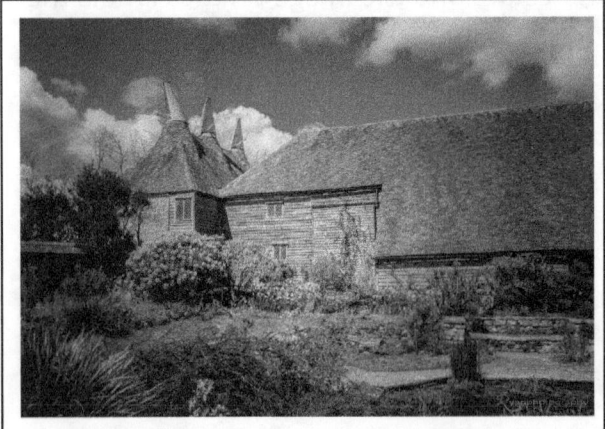
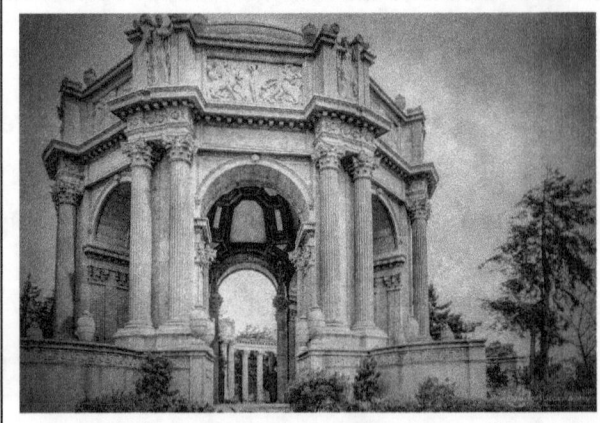

Landscapes

Well this has to be my favourite form of photography... I love landscape photography and earlier in our Flowers and Trees section... I posted some photographs of Yosemite National Park..

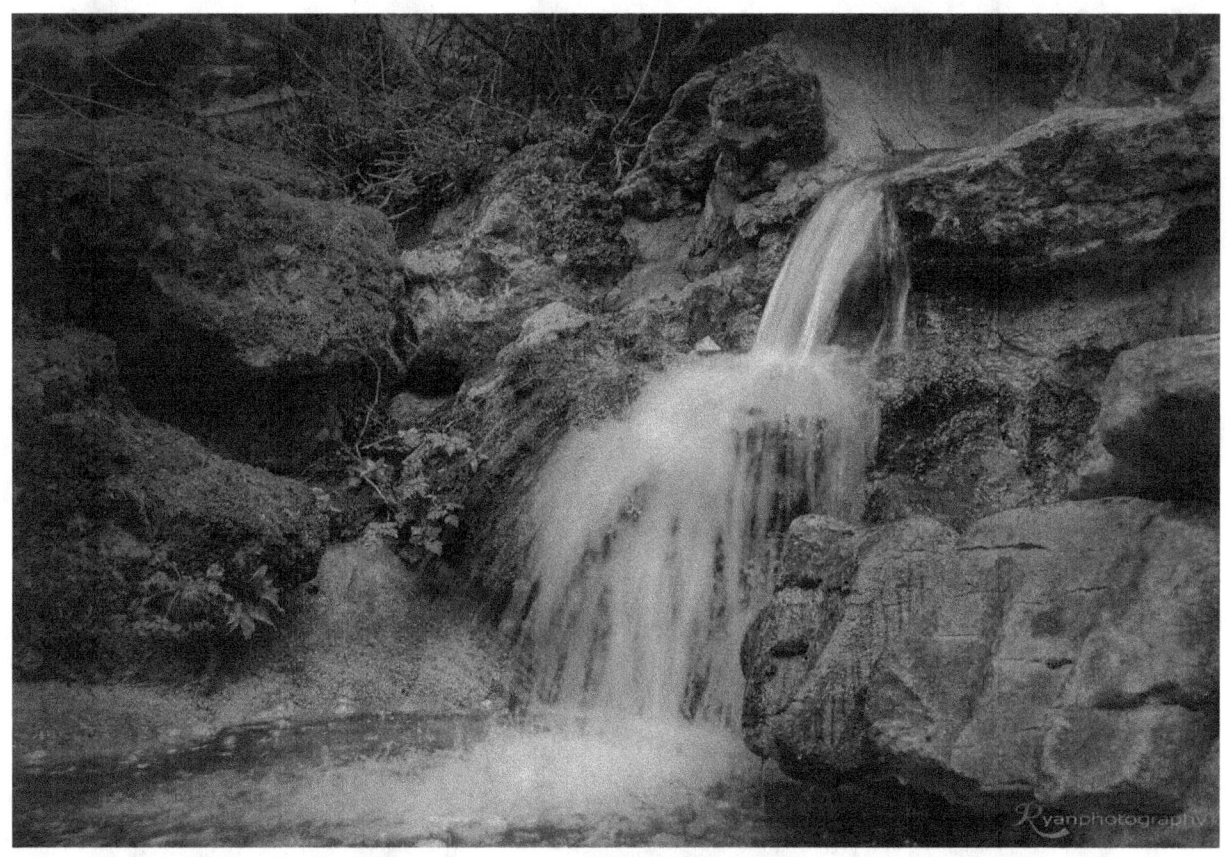

Whether it be waterfalls or landscaped gardens.. I just love taking scenic shots. Beauty is all around us... and like flowers.. Some scenic shots... just don't look right in monochrome. So again experimentation is the way to go... convert a photo to black and white and change the hues of the colours... I have learnt that experimentation is a great learning tool and a good way to learn your software inside and out.

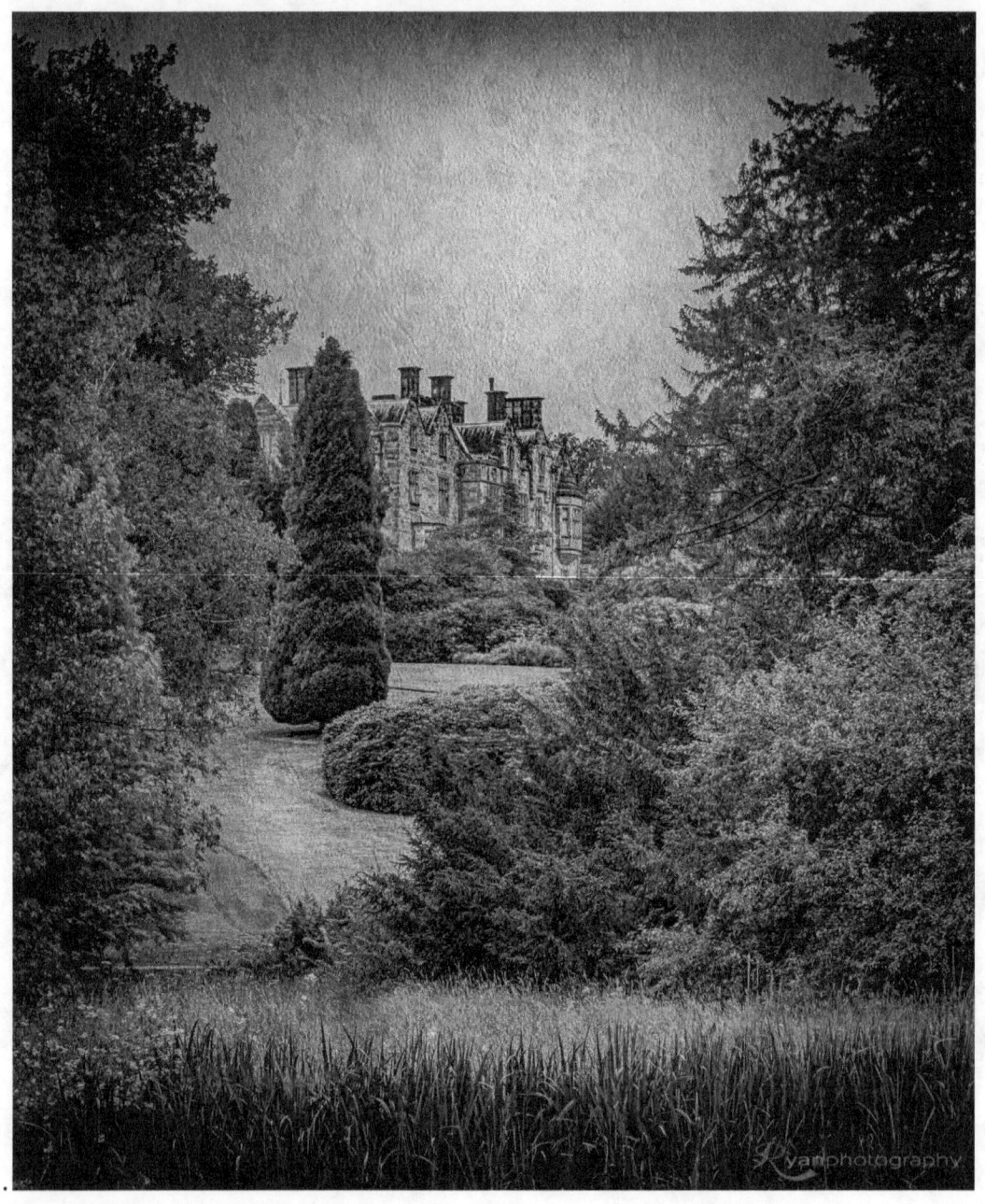

The above photograph has everything in it... architecture, flowers, trees and it creates an ideal landscape image. One thing I did do to this photograph was this... I added a texture to the image in Photoshop... I did this primarily because the sky was boring and needed some oomph in it.

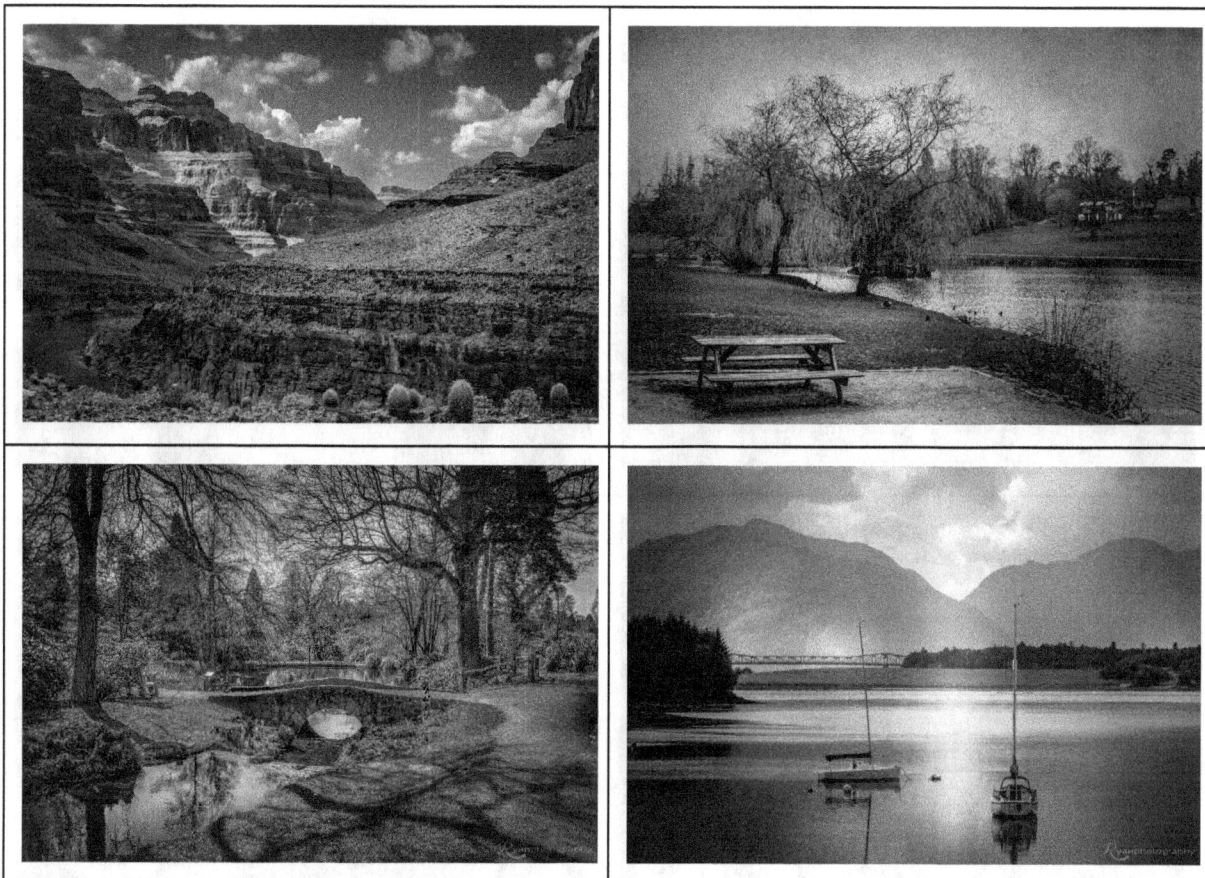

The above photographs are

- Top Left - Grand Canyon - West Rim
- Top Right - Dunorlan Park near Tonbridge in Kent
- Bottom Left - Wakehurst Place in West Sussex
- Bottom Right - Boats on Loch Leven near Glencoe Scotland.

Landscape photography is everywhere... fields, hills, mountains... you name it You can photograph it. Landscape photography is to me... a wonderful subject to master... I think out of Architectural and Landscape Photography... landscape really enthrals me... I love just venturing into the unknown and seeing what there is to photograph.

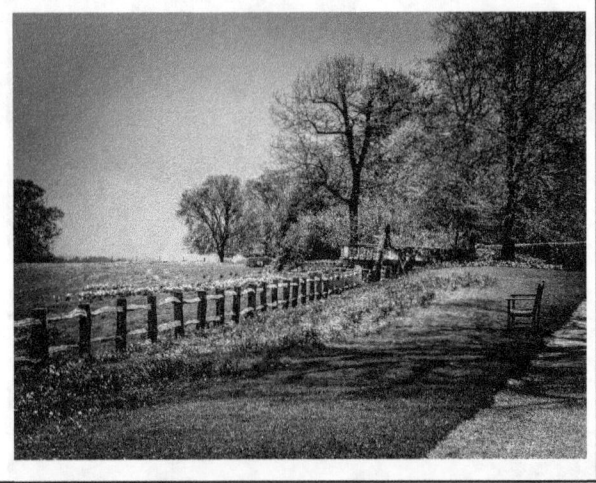
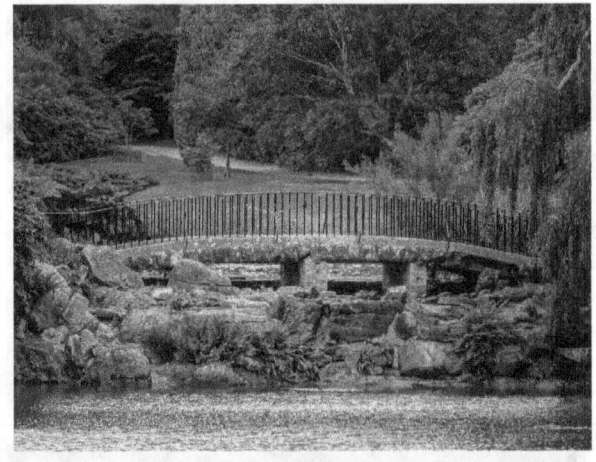

- Top Left - Nymans in West Sussex
- Top Right - Wakehurst Place in West Sussex
- Bottom Left - Ightham Mote in Kent
- Bottom Right - Herne Bay Promenade in Kent.

Animals and Wildlife

Well when it comes to taking photographs of wildlife... for me it is a bit hit and miss... sometimes I get the shot and sometimes I don't and it is a subject that I really do need to practice and master.

However when it comes to capturing the dogs.. Then I must have the most obedient pets going because they stand perfectly still.

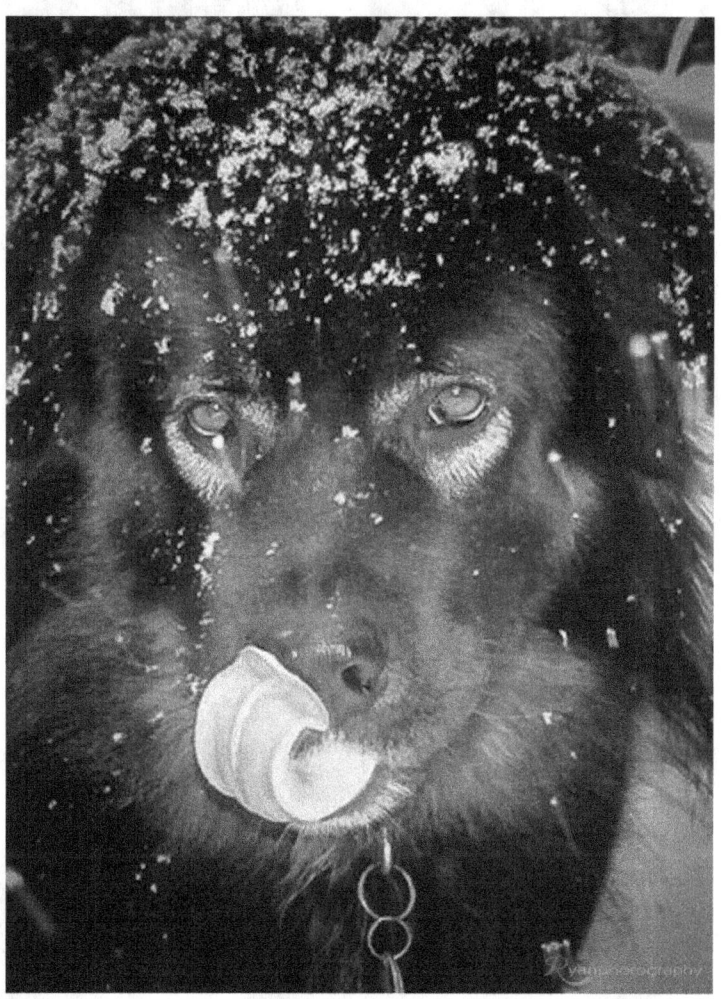

My boy - God rest his soul.. Loved being photographed.. He would pose and basically get in your way and become a perfect nuisance until you photographed him.

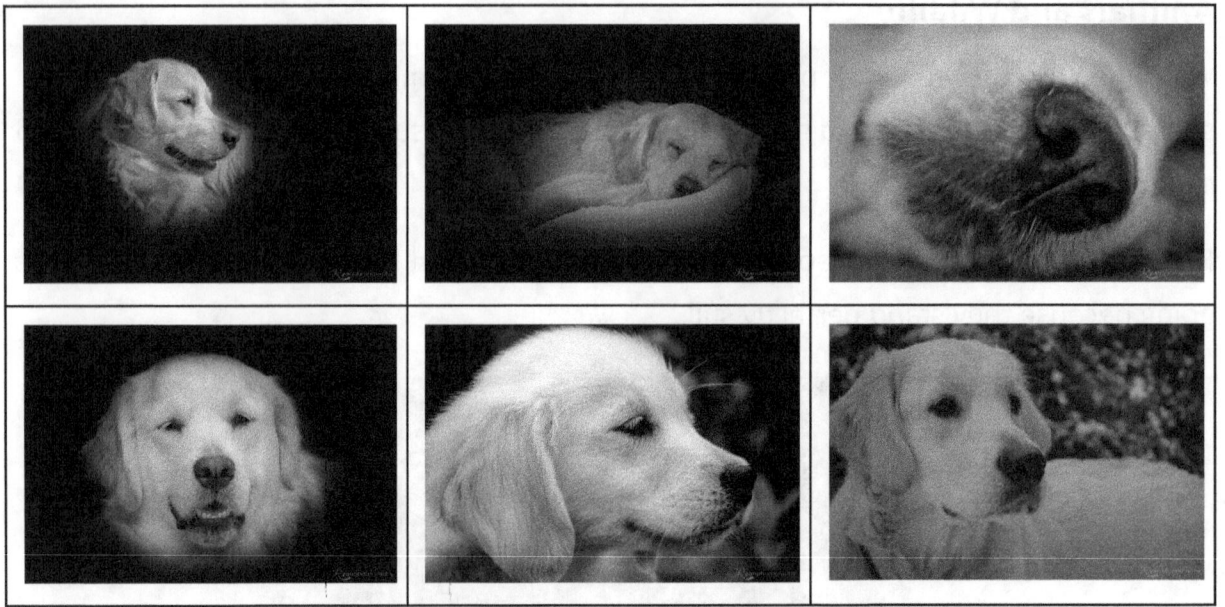

My two Golden Retrievers also like having their photograph taken and I just love this shot of my Stewie

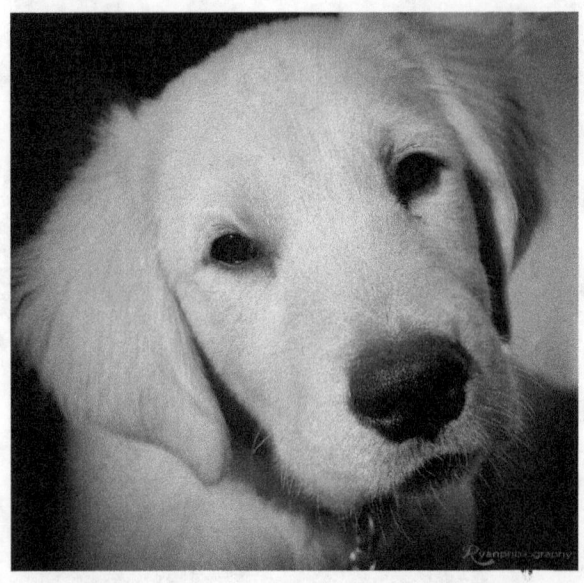

And how he is looking so tentatively at me...

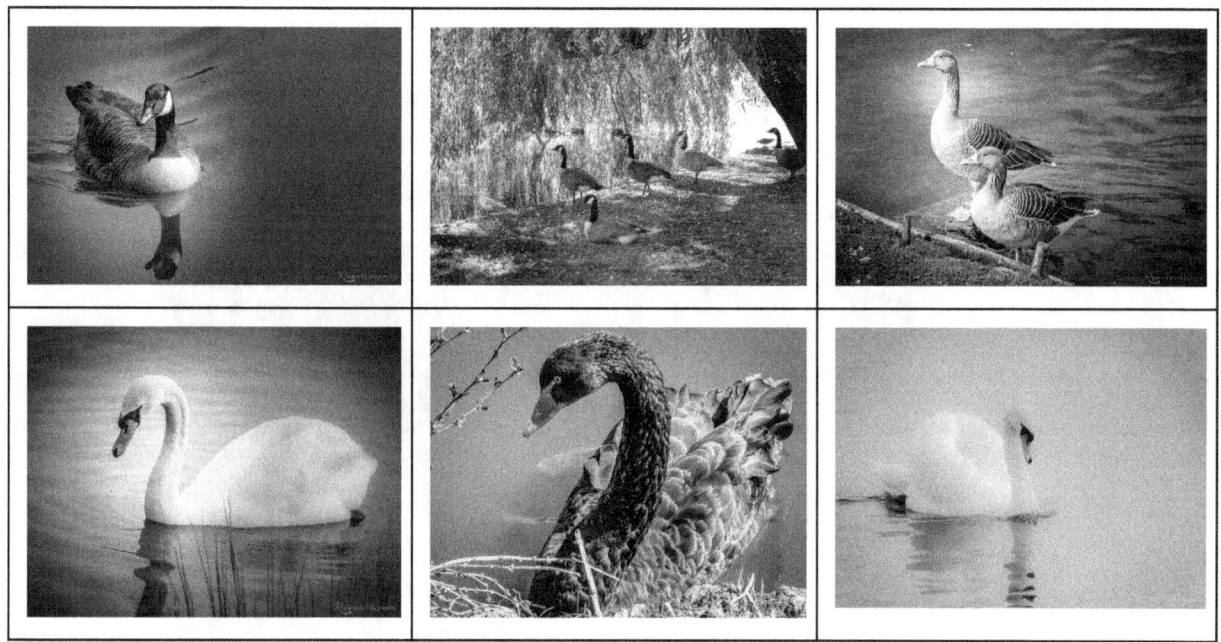

Ducks, Canadian Geese.. Swans sometimes I have luck with..

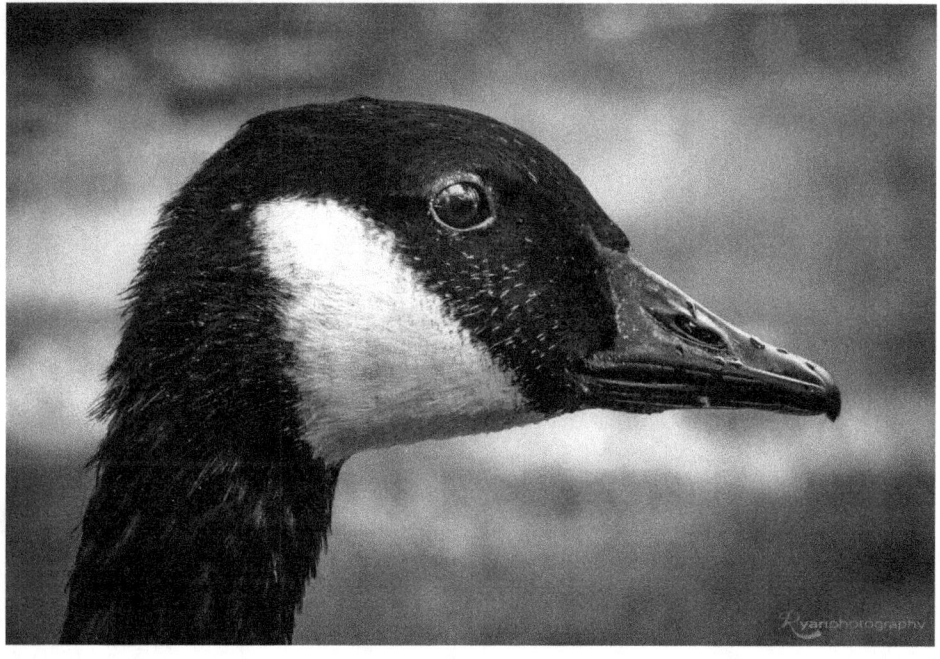

And this little guy was definitely a poser... as he wandered up to to the other half posing.

But I think one of my favourite photographs of all times has to be this Little Egret... which was taken at Northward Hill Nature Reserve near High Halstow in Kent.

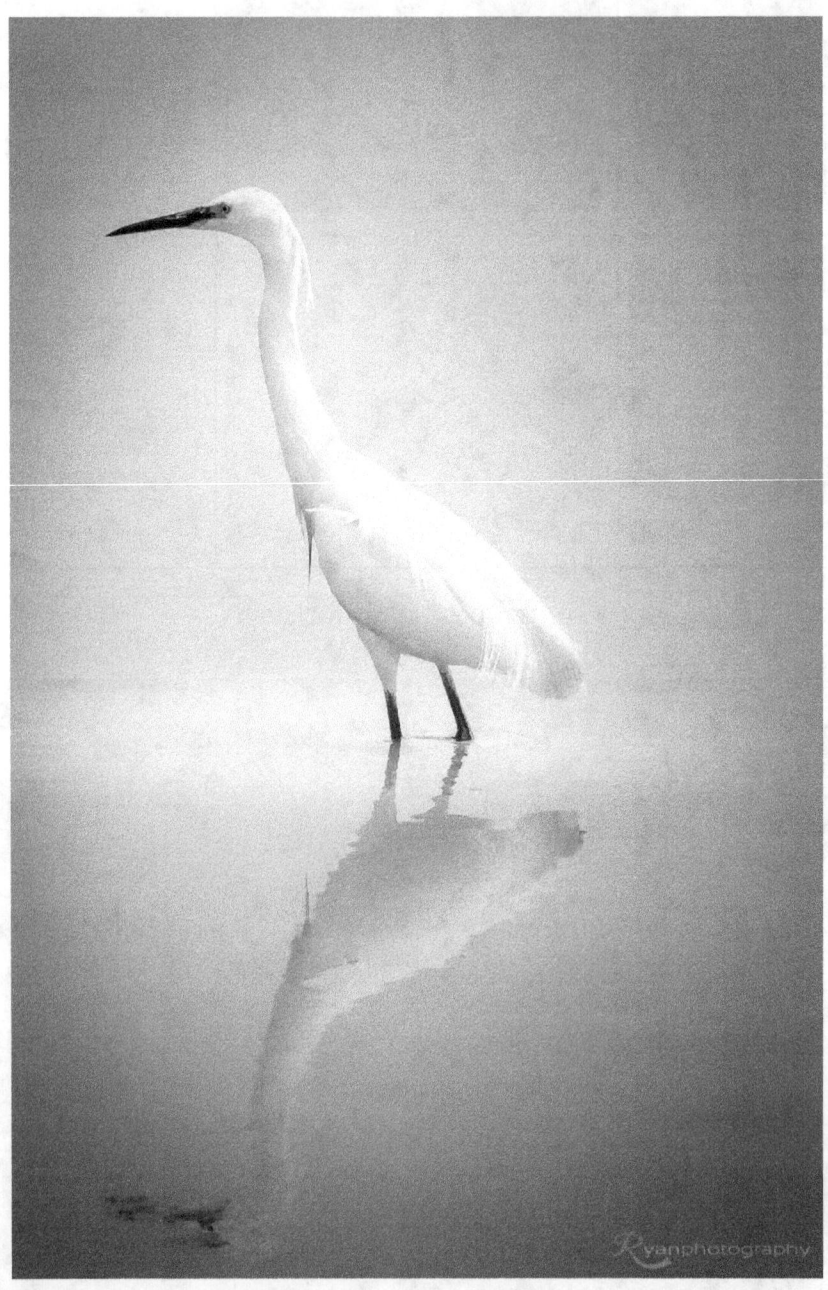

And the reflection of him in the still waters of the swamp is awesome.

Fine Art Photography

You have taken your photos .. you have shown them to your friends and family... You might've even posted them on a blog you curate... but what next? What else can you do to them. Well what I like doing to photographs is adding texture to them... or drama in some form or another.

You can add textures using Photoshop, GIMP or Photoshop Elements.. Well to be honest any software that allows you to add layers and change blending modes. The internet is full of sites where you can download free textures to add to your photographs... Flickr.. Deviant Art... and one particular site I use Public Domain Textures.

The two blendings modes that I use mainly are Multiply and Soft Overlay... Multiply will darken the picture but you can in Photoshop alter the exposure and the contrast to compensate for this.

If you are using Textures then learning about Luminosity Masking is a must... one of the plug-ins that I use in Photoshop for this is Greg Benz's Lumenzia. You can also download his Free Luminosity Masking Panel... but just a tip here... when you create your masks and you have finished with them... use the clear masks button in the panel... otherwise you file size will increase massively.

By varying the fill and the opacity of your layer, you can easily achieve the result you are looking for. Most of my texture adding to photographs is used mainly in colour photography.

Sometimes you can achieve the effect you desire by combining two textures together and blending them together... You do this by using creating a new layer for each texture and changing the blending mode. Learning about clipping masks in Photoshop is vital for this.

You can also add elements to your photograph to give it a whole new meaning... For instance in the image on the following page... which is of a woodland... I added a child and then added to ghost like figures..

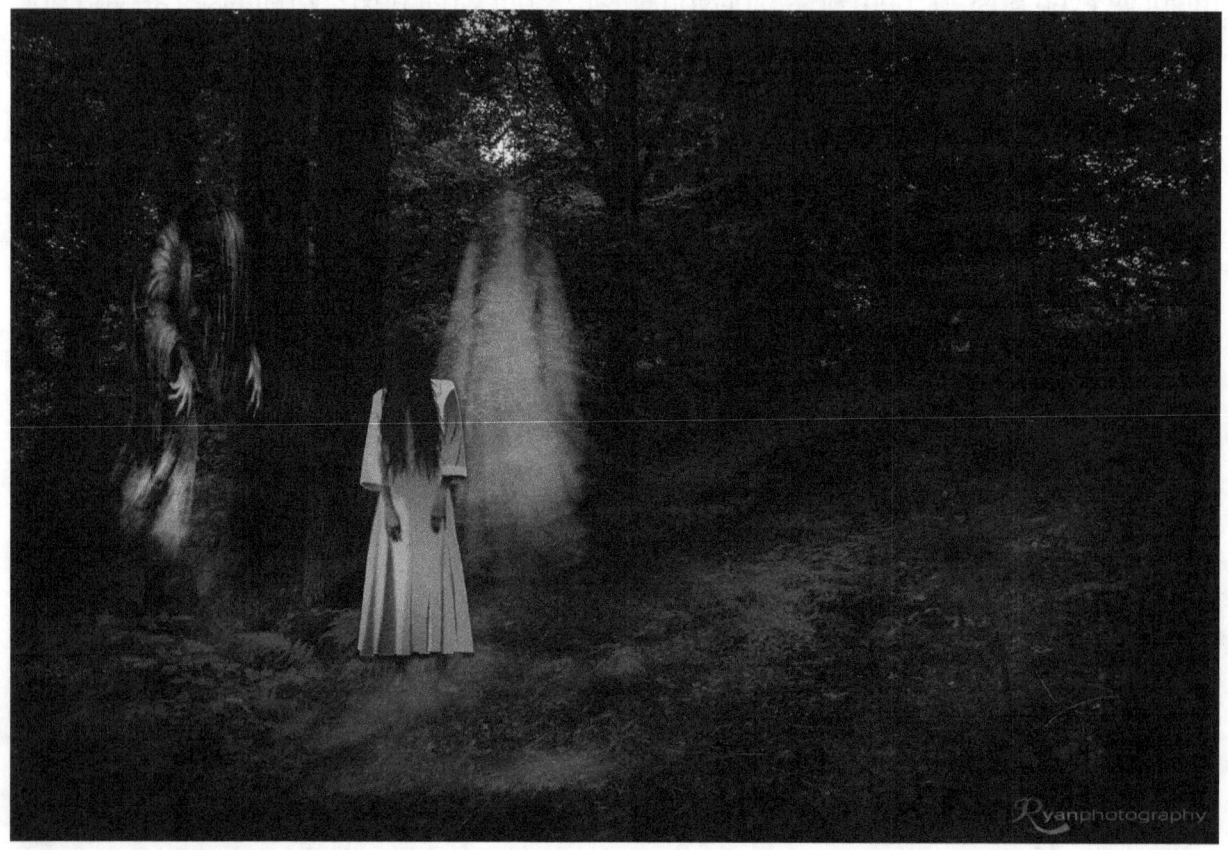

By adding those two figures it was to represent Good -v- Evil and the choices we have to make.

Fine Art Photography is not for everyone but I love creating things.. I love letting my imagination wonder... I love to see where a thought and a photograph takes me... And I love to experiment!

If you use Lightroom, there is an excellent edit feature, where you can edit in Photoshop. Lightroom will automatically send you image to Photoshop where you can create your Fine Art.

The process is simple really and once you have selected the photograph you will to work on in Photoshop.. Right Click and select Edit In..

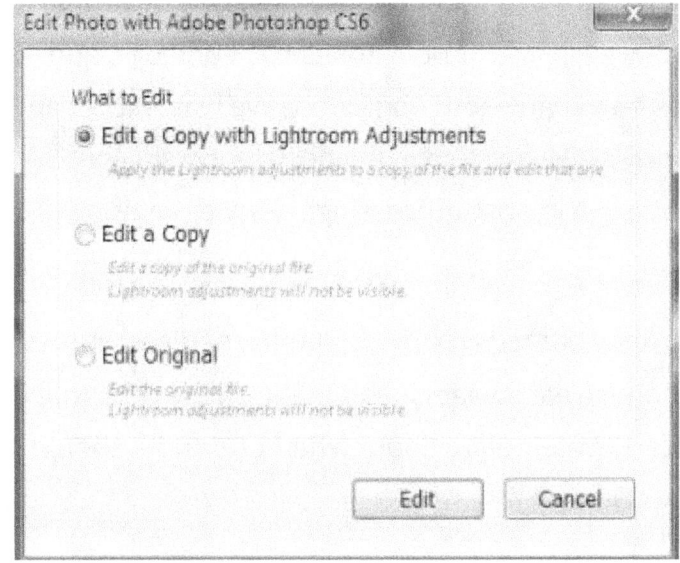

Always select the option *Edit a Copy with Lightroom Adjustments'*. This will export your Photograph into Lightroom with all your Lightroom Edits ..

Now just a word to the wise here... if you use the Book Module part of Lightroom and you have created a document in Photoshop.. Beware the Book Module DOESN'T recognise Transparent Layers... and it will ask you to Flatten your Image before uploading your book to Blurb or a PDF. (I found this out the other day and spent half of the day having to go back through my photographs edited in Lightroom and Flatten them.

It is a tossup here really... if you flatten your image.. If you decide to go back into Photoshop you can't edit the layers in the future, should you say wish to rework a particular layer used on the original photograph. So it is either flatten so you can use the module or don't flatten so you can edit later on..

There are many sites out there dedicated to Fine Art and it is one concept of Photography that I love to partake in...

As I said Fine Art Photography is not for everyone but give it a try... you might actually enjoy doing it ...

Final Note

When we started out on our journey of Photographed we knew nothing...when I started out on my journey of post-processing I knew even less. But as times has gone by... and lessons have been learnt... and god knows how many YouTube videos I've watched... I am more confident.. Not just in my photography skills, but also in my post-processing of photographs. I am also developing my own style in post-processing... a style that is unique to me... a style that I love.

I run a blog which showcases our images, aptly named RyanPhotography and sometimes I look over posts written back in 2012 and those early years... and think Oh My God, that photograph is absolutely abysmal and then I contemplate about whether or not I should delete those posts and photographs? Do I? Don't I?

Then a wave of thoughts comes across me... and I think about how much I have learnt, how I now understand, composition, Lightroom, Photoshop, and all those things I was so frightened of in the beginning.

I look and see the progress we have made on our photography journey and how our photography has improved. Those photographs are part of our journey and part of my processing skills... so they are staying... the show the complete road to learning how to take a photograph.

Photography to both of us is a hobby... a hobby we love... would we like to do this on a professional basis... to be honest I don't know... but I like what we are doing now... and for the time being I am quite happy and content to plod away and learn new skills.

Who knows what the future holds.. But I sure hope it is a fun as the last few years..

References

When we started out on our photography journey, we both knew nothing... we relied solely on the expertise of others.. Great photographers who freely gave their time, their expertise and who have produced good quality instructional videos and written instructions on how to do things. There are many to thank... and that would be an entire book within itself.. But our gratitude goes to the following people..

> **Serge Ramelli**, a French photographer, who runs a website called Photo Serge. Serge offers paid tuition as well as free videos, where he explains how to transform a normal image into a masterpiece. His free tutorials can be viewed on YouTube and if you sign up to his newsletter you can get many of his sources files to work on and practice with, as well as free Lightroom Presets. I have learnt a lot about Lightroom from Serge and my heartfelt thanks goes out to him for providing free tuition.

> **Matt Kloskowski**, Matt used to be part of Kelby Media and then moved to On1 Software. Matt whilst writing for the blog Lightroom KillerTips gave away many Lightroom Presets as well as tips and tutorials for Lightroom and the occasional Photoshop tip thrown in for good measure. At the moment Matt is doing a lot of Youtube Videos called *60 second Tips for both Lightroom and Photoshop*.. Which I am finding very invaluable. Again much appreciation sent to Matt for what he does in helping us amateurs gain confidence. And his wonderful tips and tutorials

> **Leanne Cole**, Leanne is a Melbourne based photographer, who has produced some stunning work.. She also provides some tutorials as well as running a weekly Monochrome Madness theme on her blog, which I do participate in occasionally. Leanne also contributes to the Digital Photography School Website. Leanne also

produces a magazine called Dynamic Range which is primarily for female photographers written by female photographers.

There are many more other people I would like to thank... Laura Macky... Stacy Fischer, Cee Neuner, Julie Powell, and many many more.. These people have given me inspiration, and please go and visit their blogs.. You will be astounded by their work..

A huge thanks goes out to everyone I have got to know in the photography world .. thanks for giving me inspiration, tips and tutorials and a special thanks goes to all the readers of our blog... RyanPhotography. Our blog wouldn't be what it is today if it wasn't for all the nice visitors I get and for all the lovely comments I receive on a daily basis.. A massive thanks to all our readers, commentators and visitors. Xx

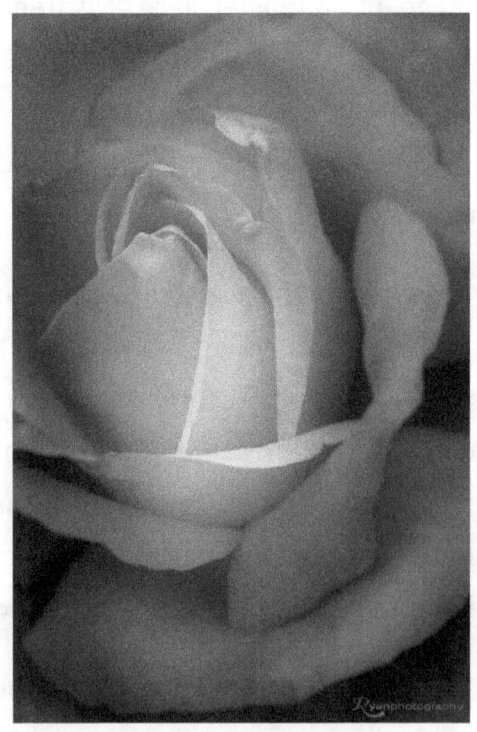

About the Author

 I am a disabled amateur photographer with a keen interest in landscape and floral photography. I live in the Kent, known as the Garden of England, in the United Kingdom. I desire to travel and hopefully one day move to somewhere where it is picturesque and a photographer's delight. I am also the female half of the RyanPhotography husband and wife duo who love to capture pictures from wherever they travel.

Index

Foreword ..1

Learning Your Camera and the Software Needed......................... 3

Software .. 4

Seascapes ... 7

Flowers and Trees ... 20

Architectural Places .. 27

Landscapes ... 43

Animals and Wildlife ... 47

Fine Art Photography .. 51

Final Note ... 54

References.. 55

Copyright © 2016 by Bren Ryan of RyanPhotography All rights reserved. This book or any portion thereof may not be reproduced or used in any manner whatsoever without the express written permission of the publisher except for the use of brief quotations in a book review.

www.ryanphotography.uk

www.ingramcontent.com/pod-product-compliance
Lightning Source LLC
Chambersburg PA
CBHW080545190526
45169CB00007B/2648